Lives of the Artists

———————

Keith Haring

Simon Doonan

Laurence King Publishing

LAURENCE KING

Published in 2021 by
Laurence King Publishing Ltd
361–373 City Road
London EC1V 1LR
United Kingdom
T + 44 (0)20 7841 6900
enquiries@laurenceking.com
www.laurenceking.com

A catalogue record for this book is available
from the British Library.

ISBN: 978-1-78627-787-9

Printed in Italy

Laurence King Publishing is committed to ethical
and sustainable production. We are proud participants
in The Book Chain Project®
bookchainproject.com

Cover illustration: Adam Simpson

CONTENTS

*This book is dedicated to the memory of
Keith Haring and all the creative daredevils
in his orbit whose lives were cut short by the
scourge of AIDS, including, but not limited to,
Klaus Nomi, Tseng Kwong Chi, Robert Fraser,
Tina Chow, John Sex, David Spada, Tom Rubnitz,
Bobby Breslau, Juan Dubose, Martin Burgoyne,
Arnie Zane and Robert Mapplethorpe.*

Introduction

It's a wet Sunday morning on 14th Street in 1983. I am spending a week in New York in order to fling myself into the exploding, neon, post-punk, downtown scene. On the corner of Sixth Avenue I run into a pal named Vikki. She is an LA good-time girl, who has recently moved to Manhattan. She tells me she has scored a job working as a go-go dancer at the newly opened Limelight, a den of iniquity located in a Gothic church on Sixth Avenue and 20th Street. Dancing on a disco cube has always seemed to me like the ultimate metaphor. Life is like a disco cube. We each get our turn. We jump up and jiggle about. And eventually we fall off, and then it's somebody else's turn. Some of us are accorded longer jiggle time than others. Fate gave Keith Haring a very truncated jiggle, brief but action-packed.

I am delighted to run into Vikki. I figure she will share intel on the burgeoning groovy scene, and I am correct. 'You missed Keith Haring's opening last night. It was insane. Look. He drew all over my shirt.' She opens her Fiorucci jacket and flashes her T-shirt, which is decorated with a series of cartoony line drawings. 'Who's Keith Haring?', I ask. 'He's like this whole thing', she explains. 'His drawings are all over the subway. I'm never washing this shirt again. He's going to be huge. He already shows at Shafrazi. You're so out of it.'

Three years later, as predicted by Vikki, Keith Haring is enjoying a meteoric rise. He has already created over 50 commissioned works in public spaces around the world, many with strong social messaging. One month after the event I am about to describe, he paints 300 metres of the Berlin Wall, in the drizzle, in front of global media. He is now the most talked-about new artist on the planet. Me? I am less out of it, and living in New York, designing window displays for luxury department store Barneys, where I frequently collaborate with artists.

On this particular occasion, Monday 10 November 1986, it's not a window display that is the focus of my attention, but a fashion show and party, staged inside the new Barneys 17th Street store, using the winding Andrée Putman-designed staircase as a runway. (Haring is pally with Putman. He knows everyone.) And it's not just one single artist. We have invited 100 artists and designers to deface, decorate or otherwise transform a classic Levi denim jacket. Participants include Robert Rauschenberg, Jean Paul Gaultier, Andy Warhol, Yves Saint Laurent and Jean-Michel Basquiat. The embellished Levi jackets will be auctioned off to benefit St Vincent's. Located two blocks from the store, this hospital is where many friends and colleagues are in the process of dying premature and horrifying deaths.

Artists embellishing clothing: it's a tad revolutionary. Hard to imagine the Impressionists daubing their signature motifs onto items of clothing for kicks, or for charity. In the twenty-first century we now take artist collaborations for granted, but back in the 1980s, Haring's heyday, it was a decidedly fresh idea. Haring is very much in the vanguard

of this art-as-product, art-for-everyone movement. This was also the year that, weathering endless accusations of 'commercialization', he opened his legendary Pop Shop on Lafayette Street, selling T-shirts and badges at democratic prices, sending shivers of disdain through the chichi salons of the art world.

That Barneys event, that parade of artist-embellished jackets worn by noteworthy celebrities such as Debbie Harry, Nell Campbell, Dianne Brill, Edwige Belmore and Kate Pierson, is forever seared into my memory. Down the stairway struts Madonna, the most famous girl in the world – blonde and sassy in fishnets – wearing a jacket painted by her old roommate Martin Burgoyne. He has accompanied her to the event despite feeling and looking very ill. Cancerous Kaposi's sarcoma lesions are clearly visible on his face. By now you are starting to get the picture: welcome to the 1980s, where the plague of the century rages against a backdrop of explosive fun, fashion and music.

Another clear memory of that evening is that the notables and artists were less neurotic and much more freewheeling than they are now. When asked if they want to participate, all the artists and soubrettes simply show up. None requires payment or town cars or coercion or free stuff of any kind. The collision of art, fashion and music is a new thing that is breathing life into the art world and the wider culture, and they are all anxious to be part of it.

And here comes Iman, one-namer and the most legendary supermodel of all time, the future Mrs David Bowie. The Somali-born goddess is floating flawlessly down the

stairs wearing a denim jacket painted by ... drumroll ... Keith Haring. The design – graphic tribal markings on a dark background – recalls the body-painting projects undertaken by Haring three years earlier on the torso of Bill T. Jones and, one year later, on Grace Jones. At the foot of the stairs, Iman encounters Madonna and they ham it up. The entire runway/stairway is a festival of exhibitionism, raucousness and *fun*. And the artist himself? I did not clock him and assumed he was probably in Paris, basking in the glamour of his one-man show at the Galerie Templon, but Ron Gallela's photo archive reveals that the peripatetic artist did in fact make an appearance, wearing a rather insouciant black chapeau.

Two years after this event, Haring is diagnosed with AIDS. Four years later he is dead. Famous at 25, dead at 31, Keith Haring's short, fabulous life – part Rake's Progress, part Pilgrim's Progress – is filled with accolades, biblical humiliation, ecstasy and agony.

A Rake's Progress, a series of eighteenth-century paintings by William Hogarth that inspired a Stravinsky opera, charts the rise and moral decline of one Tom Rakewell, a spunky lad who is seduced by the delights of London, meets the devil and ends up totally bonkers. The moral? 'For idle hearts and hands and minds the Devil finds work to do.'

Haring had an undeniably rakish side. He was an enthusiastic substance abuser and a full participant in the sexual liberation that kicked off in the late 1970s. After moving to New York City he finds an apartment directly opposite the notorious Club Baths, the *ne plus ultra* of orgiastic gay fleshpots, and takes full advantage of this opportune/

inopportune location. Haring, however, could never in a million years be described as idle. *Au contraire* – his life was lived at warp speed. His artistic output was relentless, and his work ethic was astonishing. His progress, as we will see, is ultimately more that of a frenetic pilgrim than a self-indulgent rake.

The Pilgrim's Progress, the most popular religious allegory in the English language, was written in the seventeenth century by John Bunyan. The powerful drama of the pilgrim's trials and temptations follows him in his harrowing journey through the Slough of Despond and the Valley of the Shadow of Death to the Celestial City and redemption.

Haring was a seeker of truth, a bloke who was looking to find Bunyan's Celestial City, even if he is compelled to paint it himself. Haring's progress was an earnest rummaging to find meaning. His pilgrimage brought him new mentors and wizards, including Andy Warhol, Timothy Leary and William Burroughs. He absorbed and discarded many philosophical ideas along the way.

'The public has a right to art. The public is being ignored by most contemporary artists. Art is for everybody', wrote Keith Haring in his journal on 14 October 1978, during his first semester at New York's School of Visual Arts. Studio 54 was raging. The Bronx was burning. The fleshpots of NYC were brimming, and Keith Haring was expressing the most uncynical, unsnobby desire to create communicative, popular art.

Keith Haring was a pilgrim for the post-disco era, a revolutionary, a renegade, an artist for the people. He was Banksy before Banksy, but an impresario Banksy, a fearless

American blue-collar lad who eschewed anonymity in favour of white-hot global recognition. He achieved that recognition by creating an instantly identifiable repertoire of symbols – barking dogs, spaceships, crawling babies, clambering faceless people – which, thanks to his drive and resilience, became synonymous with the volatile culture of the 1980s. Like a careening, preening pinball, Keith Haring playfully slammed into all aspects of this decade – hip-hop, new wave, graffiti, funk, art, style, gay culture – and brought them together. And he was prescient, as exemplified by his passion for collaboration and commercialism. Haring's fanatical drive propelled him into the orbit of the most interesting people of his time: Jean-Michel Basquiat and Kenny Scharf envied him; William Burroughs and Richard Avedon collaborated with him; Cher, Dolly Parton and Michael Jackson hung with him; and Madonna and he shared the same tastes in men.

Haring and his pal Madonna were from that last genera-tion of groovy vagabonds, young visionaries who fled their homes and families and struck out on their own. No cell phones, no texting mom and dad for advice or handouts. They, the marginal misfits from the small towns, charged off to the big city and grabbed it by the throat, very much in the same manner as the Warhol boomer generation.

Comparisons of Haring with Warhol are inevitable. There were obvious similarities: they were both gay, born working-class, obsessed with fame and the development of a persona. In their art, however, they were opposites: Warhol took ordinary things – soup cans, pop icons – and elevated them, giving them an importance and gravitas that was

camp and amusing. Haring took serious, important things – AIDS, inequality, crack – and made them approachable, playful and bearable.

While Warhol appeared somewhat unnerved by children, and never featured them in his oeuvre – unless you count the cherubs in his early illustrations – Haring is remembered as a veritable Pied Piper. Children played a huge role in his pilgrimage. It is hardly surprising that his most famous symbol is the Radiant Baby. Haring was an unpretentious communicator who appeared happiest when mentoring a gang of kids, arming them with brushes and attacking the nearest wall, creating his Celestial City.

1

The Radiant Baby

Keith Haring's childhood dripped with twentieth-century Americana, a bit like a Bruce Springsteen song. He was born in the USA – on 4 May 1958 in Reading, Pennsylvania, and raised in nearby Kutztown, population 3,000. His parents, Joan and Allen, met at high school and began dating one year after graduating. At the time of Keith's birth, Allen was in the Marines. After returning home he joined Western Electric (subsequently AT&T), and became a manufacturing supervisor. Joan thought of becoming a teacher, but surrendered career aspirations to the more challenging roles of mother and homemaker. Mr and Mrs Haring – American, blue-collar, earnest – worshipped at the United Church of Christ.

Joan and Allen had four kids: Keith, Kay, Karen and Kristen, the Ks of Kutztown, with a best friend named Kermit. So many Ks. Squinting backwards through the lens of contemporary culture, it's hard not to view the Haring ménage as if it were some kind of Norman Rockwell version of Kim, Khloé, Kourtney, Kendall et al. Comparisons with the Kardashians are not entirely without merit. Keith's immense drive, professional and sexual, his self-belief and his commercial instincts would later match those of any Kardashian. But let's not get ahead of ourselves.

Allen Haring, a good-natured dude with a crew cut and conventional aspirations, was a committed dad and a talented amateur artist. As a kid Allen had demonstrated some of the single-minded artistic commitment that would later characterize his son's career. His first set of oil paints was purchased with funds accrued from trapping muskrats. Surely only a handful of artists, amateur or professional, can make such a claim.

Allen Haring loved to draw cartoons and passed this passion on to his only son. By age 1, young Keith is already sitting on Dad's knee and doodling. They play a game they call 'putting down lines': you do a line, now I do a line, a strange harbinger of future cocaine consumption. Young Keith develops a voracious enthusiasm for drawing that has all the earmarks of an addiction, albeit a positive one. Cartoon drawings of dogs and dragons fill the house. Astonishing quantities of pencils are consumed, to be replenished by homemaker Joan.

The glimmerings of a signature style begin to emerge. Keith's first artistic inspiration comes from comics and TV cartoons of the 1960s, including Daffy Duck and Bugs Bunny. Keith favours the stylized graphic simplicity of Dr. Seuss and Charles Schulz over the more detailed, filled-in Dick Tracy or Batman cartoons. For Keith it is all about the outline. His imagination is fertilized by the preposterous fantasy TV shows – *The Addams Family*, *I Dream of Jeannie* and *Mister Ed*, the talking horse – that prevail in the 1960s. Unhinged narratives and sci-fi iconography worm their way into his developing consciousness.

His passion for drawing remains consistent and obsessive. Teachers remember him as highly motivated, single-minded and resistant to guidance or direction. Keith, with his lines and interlocking shapes, is clearly on a mission. In junior high school he draws a continuous cartoon strip, using ball-point pen, on a 15-foot-long roll of adding-machine tape. With its depiction of the ongoing war between the hippies and the cops, Keith unwittingly creates a countercultural version of the Bayeux Tapestry, the 1,000-year-old record of the Battle of Hastings. For his efforts Keith wins an art prize. He later wins a prize for a map of the United States, which is decorated with symbols – a Mickey Mouse indicating Florida – an early example of his desire to combine art and information in a communicative, simplified fashion. Eight years later, when he careens into the School of Visual Arts in New York City, he will write explicitly about his approach to symbolism in his journal, concluding that 'Keith Haring thinks in poems / Keith Haring paints poems'.

Back to 1970: when Keith is 12 years old his youngest sister is born. The Haring household is out of bedrooms, so Kristen sleeps with Keith. Kay and Karen are off doing their own thing. Kristen becomes her brother's project, his radiant baby. As soon as she is able to clutch a pencil, Kristen sits on Keith's knee and they play 'stop and switch' drawing games. He mentors her and lectures her about the importance of curiosity. Always pick up scraps of paper that are blowing down the street: you never know what's written on them. Keith is a seeker, a boy on the lookout for messages and signs, and he wants to make sure Kristen develops a similar, nuanced, non-Kutztownian world-view.

Keith's childhood is happy, but not perfect. Although Haring resents his mother's turn-down-that-music nagging and her bossy attitude towards his father, the atmosphere chez Haring is playful and stable. Mealtimes are regular. Backyard carnivals are followed by trips to buy ice cream. The Ks enjoy an old-fashioned childhood in which kids are central. Allen's enthusiasm for children passes easily to his only son. It is hardly surprising that throughout his short life, Haring, with his radiant baby and his love of kids, comes to view childhood as a sanctified, privileged state. He believes that kids are blessed with finely tuned survival instincts that enable them to sense negative energy and bad people. He feels that kids have a more sophisticated sense of humour than adults. Kids radiate honesty and imagination, hence the radiant baby. While other teens flee from younger siblings, Keith loves nothing more than to unfurl a roll of toilet paper and encourage the kids to draw, draw, draw. Later, at fancy art-world dinners, he will invariably retreat to the kids' table and make art.

His Americana childhood was not without complexity. A gay secret was lurking behind those nerdy glasses, always threatening to manifest itself. His parents later expressed regret at not having pushed him out of the female-dominated household to spend more time with boys. I would guess, however, that Keith's consistent disinclination to make butch choices during childhood suggests that the gay dye was already cast.

When Keith is a pre-teen, he begs for a Ken doll. Granny buys him one. Mom, ever conscious of the need to mas-culinize her only son, goes nuts. Like any nascent gay of

his generation, Keith longs for stylish new bell-bottoms. Sadly, he is compelled to wear his uncle's threadbare hand-me-downs, a fate worse than death for any homosexual. At church camp Keith surprises his co-religionists when he drags up as a woman, pops out of a cardboard cake and executes a striptease. Watching Dave, the camp counsellor, showering outdoors makes him tingle, as do the interludes of nude swimming with the hometown wrestling team.

His fangirl obsession with The Monkees becomes overwhelming, especially with regard to heartthrob lead vocalist, Davy Jones. With his dark hair and thick eyebrows, Jones, the charming runt of the group, is warm-up for the compact Latin boys who would dominate Haring's later romantic life. His uncomprehending struggle with his homosexuality – something's bubbling up and I know I must tamp it down and make it go away or catastrophe will engulf me – is no different from that of any gay boy growing up at this time. Nursing his terrible secret occupies a large part of his waking thoughts, as does the managing of his considerable sex drive. On his paper round he stops off at public bathrooms and masturbates compulsively.

Keith's homosexuality plays a significant role in propelling him out of smalltown America and ensuring that he does not end up at AT&T. His talent, combined with his need to find and express his most authentic self, leaves him no choice. He is destined to become a pilgrim, and a rake, and to leave the 3,000 worthy people of Kutztown in the dust. But not quite yet.

Teen Keith begins to feel that there has to be a world beyond Kutztown. He eventually finds it in his granny's

Look and *Life* magazines. Although his hard-working parents are largely oblivious to the 1960s cultural revolution, the same cannot be said for his groovy grandma, giver of the Ken doll. By the age of 10 he is poring over powerful black-and-white images of student riots, transvestites and other cultural phenomena.

And what of Art? A visit to the Hirshhorn Museum in Washington DC with the church club exposes him to Warhol and a cluster of *Marilyns*. This encounter with Pop Art makes a huge impression. Here is an artist who blurs the lines between fine art and the commercial world. After this trip, Haring becomes less interested in 'cartooning for cartooning's sake' and more convinced that he can develop an artistic style that places his cartooning skills into a legitimate artistic context. He feels that he can become – or maybe already has become – an artist. He begins to experiment with abstract shapes. He discovers the Rapidograph, the magical pen with the consistent black line. His teachers find his drive noteworthy. 'Yes, Allen Haring was undeniably artistic, but Keith had the goods to go out and do something about it', recalls junior high school teacher Lucy De Matteo in John Gruen's authorized Haring biography.

The notion of belonging to a group begins to take shape in teenage Keith. After watching the brutality of the Kent State shooting on TV, he feels the urge to become part of something. Religion is all around – Kutztown is in the heart of Mennonite country. Keith grows up seeing the mysteriously attired devotees riding horses and buggies. He eschews these options and begins hanging out with

the local Hare Krishnas. Then he becomes a self-described Jesus Freak.

As a born-again Christian, Keith feels the need to integrate his new belief system into his art. Crosses and Jesus symbols proliferate in his drawings. He also sets about spreading the word to friends and family. Evangelist Keith sermonizes to his mystified relatives, making sure they are fully aware of the Second Coming and, of course, the rapturous end of the world. This short-lived feverish interlude flummoxes his family but leaves a lifelong impression on his imagination. Religious imagery – miracles, transformations, conversions – remained central to his work throughout his life.

Aged 15, Keith takes his missionary zeal and applies it to a less salubrious context: he becomes a devotee of drugs – pot, angel dust, acid, Seconal and 'black beauties'. He hangs with bad kids and begins to drink before going to school. This self-destructive nosedive generates painful conflict and ugly scenes with his parents. He screams insults at his mother. His dad strikes him. His artist pal Kermit, who becomes alienated from him during this druggy period, recalls Haring arriving late (again) at school one day, possibly high on angel dust, and telling the principal in a sincere and straightforward manner that he had been 'captured by terrorist rabbits'.

This period ends when he takes an after-school dish-washing job at a local landmark, a kitsch Pennsylvania-Dutch-themed restaurant named the Glockenspiel. This improbable location brings him into contact with older college kids who are groovier and less nihilistic than

his local Kutztown druggy pals. Keith, the seeker, the introspective kid, finds he has more in common with these hipper kids. Goodbye Kutztown riff-raff. He begins taking drugs with smarter people – dropping acid in order to expand the mind, as opposed to pounding it with god-knows-what in order to obliterate it – and things improve. He reconnects with Kermit.

A word about Kermit, the artist bestie from childhood: Kermit Oswald will remain in Keith's life right to the end. His recollections about Keith – the dork, the nerd, the individual – help to paint a picture of Keith's personality. What is he actually like? In Gruen's rich biography, Kermit describes his lifelong pal: 'There was always something interesting about Keith. It was the way he dressed, the way he talked, it was the way he would smile, smirk and roll his eyes.'

The summer of 1975. The year before graduating high school, Haring – suffocating and alienated by smalltown scrutiny – embarks on a Jack Kerouac journey. He secretly cashes in one of his savings bonds, which yields $700. He takes a chunk of this money and buys half a pound of marijuana and buries it in the backyard. One night he digs up his pot, packs his bags, slinks out of the house and flees with a pal to the Jersey Shore. Haring describes the subsequent summer as 'the most wonderful experience of my life'.

The Jersey Shore teaches him life skills and financial responsibility. Despite having cash in his pocket, he gets a job as a dish-washer. His work ethic and willingness to take menial jobs in order to move forward in life is a leitmotif of his early progress.

Keith encounters Jews for the first time, finding them stimulating and creative. With his new pals, he continues his drug odyssey, taking substances in a way that expands his mind and his artistic horizons, smoking pot and dropping acid and staying up all night, chatting with his new Jewish pals and watching the sunrise. Haring's Jersey Shore – intellectual salons on the beach – provides a counterpoint to contemporary perceptions, which have been coloured by the eponymous reality show.

During that summer, Keith also gets a taste of rejection. He recalls how he and Morty Fishman would head to the local shopping mall and attempt to pick up girls, with mixed results or, in Keith's case, no results. Haring is confronted with the fact that girls do not make passes at skinny nerds who wear glasses.

Haring returns to Kutztown a changed person. He has a tearful reunion with Allen and Joan. He reunites with Kermit and they develop a deeper, artistic, intellectual connection. He listens to the Grateful Dead, he takes more drugs and hallucinates and thinks about life. He applies to art school.

2

A Portrait of the
Young Man as an Artist

There is no evidence to suggest that making Art will pay your bills. In fact, there is every reason to suppose that it will not. History is littered with the corpses of destitute artists who pursued their passion and expired as a result. Not only is the life of an artist financially precarious, it is also emotionally perilous. The pursuit of art for art's sake – squatting alone in your studio for hours on end obsessing about your technique – has sent many artists into a spiral of alcoholism, despair and madness.

When Keith's parents and his high school guidance counsellor pressure the graduating Keith into pursuing a career in commercial art, as opposed to fine art, you cannot really blame them. They are just being pragmatic. Young Keith, with his history of impulsive behaviour and drug-taking, needs structure and financial stability far more than he needs creative expression. And maybe Keith on some level agrees. Either way, he permits himself to be talked into enrolling at the Ivy School of Professional Art, which sounds like a Swiss finishing school, but was instead a commercial art college in Pittsburgh.

In early September 1976, at four in the morning, Allen drives Keith to Pittsburgh. Ma Joan stands at the kitchen door and sobs as she waves goodbye. The outpouring of emotion is a cathartic processing of the agony her delinquent son inflicted on her six months earlier, and an expression of relief that he is now – fingers crossed – on a more stable footing.

Though not ecstatic about his new school, Keith enjoys the art school milieu, and makes full use of the facilities. In addition to the commercial courses, there are basic fine art classes in painting and drawing, where Keith is able to develop his drawing style and his repertoire of imagery.

He might well have continued at the Ivy were it not for the world-view of the other students. Their stated ambition – we will use our future commercial employment to pay the bills so that we can develop our real art in our own time – causes Haring to reflect. He understands himself well enough to know that if he works a day job, slapping down paste-ups and mechanical layouts in a commercial environment, he will have no interest in working on his 'real' art in the evenings.

Home for the holidays, Haring happens upon a book by Robert Henri at a Kutztown flea market. Henri was a notable American painter, whose luscious portrait of Gertrude Vanderbilt Whitney hangs in the Whitney Museum in New York. In the 1920s, he wrote a book titled *The Art Spirit*. Henri's philosophical ideas about being an artist, and teaching art, speak directly and reassuringly to Keith, addressing his internal dialogues and questions. As is so often the case in Keith's life, a vital, galvanizing message

has been delivered to him in a mysterious fashion, and he hears it as if it had been yelled through a megaphone directly into his ear. With only two semesters under his belt, Keith quits the Ivy, throws his battered copy of *The Art Spirit* into a bag and sets off on a hitch-hiking pilgrimage. Accompanying him is his new girlfriend, Susan.

Keith had met Susan when he first moved to Pittsburgh. She was the first girl who saw past his nerdy façade and realized that there was something rather cute and exceptional about Keith. He promptly lost his virginity and fell in love. They had lots of sex, which Keith enjoyed. At this point in his life he still felt sure that, even though glimpses of male flesh in *Penthouse* magazine made him tingle, he was destined for what is now known as heteronormativity.

Keith persuades Susan to accompany him on the trip. Their stated mission is to check out alternative art colleges around the country. Hitching and sleeping in a pup tent, they fund their trip from the sale of T-shirts – a Grateful Dead homage and a Nixon-sniffing-a-kilo-of-marijuana design – which Haring has printed and schleps along in his backpack (a hippy harbinger of his Pop Shop, which is still a decade away).

Their travels take them to Minneapolis, South Dakota, Montana, and then Berkeley. Here they crash with a minister whose address they find on the Berkeley campus bulletin-board. This man of God has an associate who makes continual goo-goo eyes at Keith. This young man takes the fresh-faced couple on a tour of San Francisco, including the sizzling Castro gay ghetto. He flirts with Keith, who responds by clinging tighter to Susan. This brief encounter

causes Haring to face the fact that while he is sleeping with Susan, he thinks only of men.

After LA, the ill-fated couple head back to Pittsburgh. They both take jobs washing dishes in a health food restaurant. Haring's willingness to fund his progress with menial jobs is always impressive and invariably brings him unexpected benefits. He next takes a job as an assistant cook at the cafeteria in the Fisher Scientific Corporation. Here he receives an important cosmic message. The dining room is decorated with murals depicting experiments in alchemy. Integrated into the artwork is a message from another ghost, Louis Pasteur: 'Chance Only Favours the Prepared Mind'. Keith adopts this quote as a personal motto.

Haring's ability to extract ideas, beauty, philosophy and positivity from crummy situations, sincerely and wholeheartedly, is exceptional. Not only is he able to uncomplainingly take crap jobs, but he mines them for inspiration and opportunity. On 13 December 1977 he has his first show, on a blank wall in the Fisher cafeteria. The exhibit is announced in the weekly menu, along with some explanatory text: 'Keith is employed in our cafeteria.' During his early career Haring is surrounded by people who only seem to want the best for him. This is a testament to his likeability. If the assistant cook were an asshole, nobody would have bothered to mention his guerrilla art show on the canteen menu.

Continuing in this lemonade-out-of-lemons vein, Keith then scores a maintenance job at the Pittsburgh Arts and Crafts Center. When not mending roofs and painting hallways, he takes classes, uses the library and mingles with the students. In fact, he becomes a student in everything

but name, while collecting his maintenance worker salary. His willingness and ability to fund his own art education in this way – unblocking toilets and emptying trash cans – is a measure of his single-minded, uncomplaining approach to life, his resilience and his inability to accept defeat.

Meanwhile, back in Kutztown, Kermit is studying art at the State Teachers College, and having anarchic impulses. Bored with the confines of the classroom, he begins defacing the floors, walls and hallways of the school using various media including chicken fat and salt water. For his pains he is admonished by the university president, stripped of his financial aid and nearly expelled. When Haring pays a visit and sees what his old pal is up to, he is blown away: 'This is guerrilla art!', Kermit remembers him saying, adding, 'Kermit, on this one, you're years ahead of your time.'

Back in Pittsburgh, Keith makes an important discovery: he realizes that he has a strong aversion to canvas – the formality, the permanence, the artistic tradition – and promptly develops an obsession with paper. This rejection of conventional canvas in favour of ephemeral materials such as paper and tarps becomes a Haring signature.

His art education proceeds apace. In the library he discovers the work of Jean Dubuffet, and is shocked and delighted at the similarity of their oeuvres, especially the interlocking abstract shapes. The work of American painter Stuart Davis, a pupil of Robert Henri, also resonates.

Curious Keith finds additional enrichment, beyond the library, in his maintenance work. This is his first close encounter with African American culture. Most of his co-workers are Black guys from the Pittsburgh inner city.

Some he finds sexually attractive, others merely affable good company. All of them seem to have a certain style and swagger – the Black and Proud flowering of the 1970s – which causes him to question his own rapidly expiring hippy-dippy sensibility. They are cool and happening and listen to funk instead of folk. How wan his Kutztownian white-bread world-view must have seemed by comparison! Surrounded by this cultural richness, he experiences that same impulse to become part of something. But what?

As with so much in his life, the answer comes in a mysterious fashion. Walking to his local McDonalds, Keith sees a piece of paper on the ground. The compulsion to pick it up and read it overwhelms him. On one side it reads 'GOD IS A DOG'. On the other side is the phrase 'JESUS IS A MONKEY'. The message is instantly clear to Keith: ditch the old hippy style and embrace the new punk/new wave attitudes that are bubbling up in music and fashion. He cuts off his long hair and buys the Devo album *du jour*: *Q: Are We Not Men? A: We Are Devo!*

As when he encountered the work of Dubuffet and Davis, Haring is most excited by artists when they validate his own direction. Is this a form of narcissism? Most likely. It is also a very human response. Being an artist can be lonely. Why not take some pleasure in finding kindred spirits? This was very much the case with Alechinsky.

The punking of Keith coincides with the opening of a landmark exhibit that blows his mind: 1977 is the year that the Museum of Art at the Carnegie Institute stages a large retrospective of the work of a Belgian artist named Pierre Alechinsky. Influential but somewhat obscure, Alechinsky

is a proponent of lyrical abstraction, tachism and abstract expressionism. He is also greatly influenced by Japanese and Chinese calligraphy. To say that Alechinsky hits the spot would be a wild understatement: 'It was the closest thing to what I was doing with these self-generative little shapes.' This encounter is a hugely important part of his artistic development and propels him – his paper obsession, his dripping ink, his intuition and spontaneity – towards becoming 'Keith Haring'. The scale of the Alechinsky exhibit gives him confidence. His work gets dramatically bigger. During lunch breaks he unfurls rolls of paper on the floor and paints and paints.

His passion, and the fact that the most motivated artist on campus would appear to be one of the maintenance men, grabs the attention of Audrey Bethel, the centre director. When a planned exhibit falls through, Audrey offers the slot to 20-year-old Keith. Suddenly he has a show at one of the most coveted spaces in Pittsburgh.

One room contains 30 black-and-white Rapidograph ink drawings. As the artist himself described, 'They were very exact and dealt mainly with positive and negative space.' The larger space contains big wall pieces, floor pieces and a room constructed out of paper. Haring admits that this work was very Alechinsky, 'but you could also see the seeds of everything that would come later'.

The trait that most characterizes this part of Keith Haring's life is his unusual degree of certainty. There is no dithering. No parsing of options with pals or hand-wringing pleas for advice. Regarding his artistic progress, he is confident and decisive to an almost frightening degree. This decisiveness he now, finally, applies to his sexual orientation.

A few months prior to the Pittsburgh show, an increasingly confident Keith makes an important decision: the time has come to sleep with a man. Once this is accomplished, he sleeps with more. He goes to gay bars. He cruises the park. He has sex in cars. Is he racked with religious guilt? Does he seek reparative therapy? On the contrary, his sexuality and his art seem to blossom in tandem. He is happy.

At this critical juncture he attends a lecture given by conceptual artist Christo, including a film about his famous early work, titled *Running Fence*. This 24.5-mile-long installation, conceived and designed by Christo and his partner Jeanne-Claude, traversed the properties of 59 baffled ranchers in California's Sonoma and Marin Counties. When Haring sees the joy and wonder experienced by the initially resistant farm folk, he understands the potential of public art to create transcendent moments for regular people. He is profoundly impressed. Art-for-the-people Keith is on a mission.

On a less beautiful note, Haring breaks up, painfully and violently, with Susan. There is no conscious uncoupling. Tearful public fights attest to Susan's love for her man and her unwillingness, despite all the gay evidence, to let him go. Haring regrets the pain caused, but knows he must yank the band-aid off and move on.

In 1978 he moves to New York in search of intensity – sexual, professional, emotional and artistic.

3

The Petri Dish

There is nothing boring about 1978. The year's note-worthy events include the mass suicide of the Jonestown cult, the arrest of John Wayne Gacy, the killer clown, and the flight of Roman Polanski to France. In the fall of this tabloid-friendly year, Allen Haring finds himself, once more, driving his only boy to college. This time, father and son are headed to the School of Visual Arts (SVA) in New York City, a significant step up from the Ivy School of Professional Art.

As previously noted, Keith is on a quest for 'intensity'. After due diligence he has made the decision that SVA is the place where he will find it. Alumni of this storied institution include a broad range of notables – Milton Glaser, Sol LeWitt, Richard Artschwager, Chuck Close and Eva Hesse being a random sample. Haring's tuition and expenses are covered by various grants and student loans. Despite the financial help, Keith's budget is tight. Dad drops him off at the McBurney YMCA on 23rd Street.

Had Keith been straight he would probably have floun-dered around trying to get a foothold for months, even years. Best-case scenario, he would have bonded with some dudes at the SVA freshman mixers. Maybe he would, eventually, have found another girlfriend. But Keith is

now gay. As a result, his assimilation is guaranteed and almost immediate. The streets of Greenwich Village are now paved with pride and solidarity. Within a couple of days, he has located Christopher Street, made friends, cruised the piers, had sex and found an apartment. Less than three days after moving to NYC, Keith and his new cohorts descend on the Y and move his stuff to a humble apartment on Tenth and Bleecker.

The next day Keith charges into the SVA, guns and Rapidograph blazing. With his single-minded attitude and his bold productivity, he impresses his teachers, many of whom are themselves quite impressive: among others, Keith Sonnier teaches performance art, Bill Beckley lectures in semiotics and Joseph Kosuth teaches art theory. Keith flourishes. He soon gets As in sculpture and video art, and a B in painting. He continues his practice of commandeering spaces, festooning walls and floors with huge, dripping scrolls. Taking over a basement space, he covers it, walls and floor, with his interlocking shapes, still abstract, but starting to look more and more like 'Keith Haring'. The obsessive impulse to cover acres of paper or endless walls with all-over interconnecting patterns prompts one teacher to cite him as an example of horror vacui, referencing Aristotle's idea that nature abhors a vacuum or an empty space.

In sculpture class he befriends fellow student and future art-world star Kenny Scharf. The two bright spots of their year have found each other. According to Scharf's recollections, not everyone was cheering Haring along in his comet-like progress. His penchant for colonizing spaces and handing out promotional photocopies to announce

his ad hoc installations gets up the noses of some of the other students.

Keith, always motivated and never at a loss for ideas, now has a fresh source of inspiration: S-E-X. As soon as he arrives in New York, his libido becomes untethered. Years of repression collide with the new climate of liberation. Barhopping, back rooms and outdoor cruising all become part of his daily routine. He speculates that 90 per cent of his time is spent obsessing about sex. Sculpture professor Barbara Schwartz asks Keith to 'choose a subject and develop it'. The next day he brings to class 300 drawings of penises. His sex drive and his creative impulse appear to stimulate each other in a never-ending game of ping-pong. In addition to his drawings, his video work becomes erotically inspired. Keith's filmed naked self-portraits send a frisson of discomfort through his performance and media classes. He describes this component of his work as 'asserting my sexuality and forcing other people to deal with it'. The revenge of the liberated gay nerd has begun.

Keith engages with dance. He becomes aware that the act of painting – especially when it involves leaping and hopping around on massive salvaged rolls of seamless photographic paper – is itself a form of choreography. He collaborates with future modern dance notable Molissa Fenley, producing work that blurs the boundaries between performance, dance and video. Fuelled by his love of club music, Keith will pose, gyrate and twirl until death.

At the end of his first year, a gay Kutztown artist pal named Drew Straub moves to NYC. Together they rent an apartment right opposite the Club Baths, and become

regulars, frequently encountering each other in this legend-
ary Sodom and Gomorrah of gay sex. In short order Haring
comes to prefer the baths over the bar scene. The democracy
achieved by forcing men to remove their clothing and
wear the same white towel appeals to his anti-class views.
Sexual energy continues to leak, nay pour, into his work.
Roommate Drew remembers Keith sitting at the kitchen
table, drawing penis after penis and listening to 'Rock
Lobster' by The B-52's over and over again.

The hedonism of the 1970s sexual revolution is going
full throttle, as is the graffiti movement. The full-scale war
on vandalizing public spaces has not yet begun, so Haring
is able to enjoy a period of unfettered guerrilla art produced
by young Black, white, Latino and Chinese kids from the
Bronx, Harlem and Brooklyn. Haring is transfixed by the
graphic, curving majesty of the spray-painted shapes and
dimensional tags that enrobe the entire city of New York,
especially the subway system and its trains (in graffiti
lingo, an artist's tag is his signature symbol). Although the
nature of the lines – spontaneous, aggressive, invariably
executed at top speed in order to avoid arrest – differs from
Haring's work, the dynamism and democracy of graffiti
energize his vision.

Sex, graffiti, and so much more. The timing of Haring's
arrival in New York – at this point in history a veritable
Petri dish of creative inspiration – is noteworthy for so many
reasons. The entire culture is shifting. Studio 54 – suave,
elegant, a place of grown-up decadence – is still raging
uptown, but Lower Manhattan is vibrating with a brand
new message, especially in the East Village. Art and rock

and punk are overlapping, as exemplified by bands like Blondie and Talking Heads. A new genre of bohemianism – fluorescent pink, postmodern, ironic, camp, new wave, edgy, infantile – is burgeoning. Adherents to this cult are congregating at ratty new clubs, namely Danceteria, Hurrah, the Mudd Club and, most significantly for Haring, Club 57.

It all happens in a Polish church located at 57 St Mark's Place. Club 57 is a madcap performance space where Haring and his pals – John Sex, Kenny Scharf, Dan Friedman, Ann Magnuson, Samantha McEwen, Tseng Kwong Chi and more – convene every night to drink (illegally), perform, collaborate, create, enjoy pansexual interludes and make total fools of themselves. The latter activity is very important. A happy Dada idiocy – celebrity bingo night, beatnik night, a black-light theme – dominates the proceedings.

This sense of joy and fun is noteworthy. After the pretentious introspections of the hippy movement, followed by the raw adolescent anger of punk, this new period is characterized by a fairground sideshow playfulness. At Club 57, being silly (creative) is more important than being cool (detached and possibly phony). The word 'groovy' comes back into fashion. Club 57 was ground zero – a Petri dish within the larger Petri dish of Manhattan – for this new, artistic, upbeat sensibility.

The legend of Club 57 continued to grow long after its physical demise. In 2017 the Museum of Modern Art paid tribute with an exhibition titled *Club 57: Film, Performance, and Art in the East Village, 1978–1983. New York Times* reviewer Brett Sokol celebrated the club's mystique and

its complex legacy, writing that 'the more distant that era becomes, the more of an iron grip it holds on the imagination of many of today's younger artists, nostalgic for a time they never experienced, even as they stew over the inequities of the modern-day art market it created.'

Scharf and Haring were leading lights of Club 57. Another artist, a bloke who was ultimately to eclipse both of them in the global art market, would soon appear on the scene. Towards the end of 1979, Jean-Michel Basquiat, unknown and unappreciated, began tagging the streets of Lower Manhattan with his poems and 'SAMO' tags. One day Jean-Michel, the outsider, attempts to bum-rush the entrance to the School of Visual Arts. He's not a student, but why shouldn't he be? Haring is taken by his plight and escorts him past the guard, whereupon the interloper immediately starts tagging the place. Basquiat's mode was often one of outsider rage, prone to defacing other people's apartments, and other antisocial behaviours. His stance is entirely understandable. Basquiat was a Black artist at a time when Black artists were all but invisible. Haring and Basquiat become friends, and shadow each other in their ascent, decline and fall.

In December 1978 Haring attends the historic Nova Convention, a three-day series of lectures and panels celebrating William Burroughs and addressing issues of chance, coincidence and language. Listening to archival recordings of the various panel discussions, I found myself baffled by the pretentious waffling of Burroughs, Leary, Brion Gysin et al. The obscurantist rambling seems like something that art-for-the-people Keith would have

recoiled from. Not so. His previous exposure to semiotics enables him to extract inspiration from this event. His enthusiasm for the theoretical demonstrates that he is clearly intent on building meaningful foundations for his future art. After the Nova Convention, Haring develops a new obsession with words and the way artists such as Basquiat and Jenny Holzer are using them. A wordy approach takes hold for a while.

The Nova afterglow produces Haring's first 'street pieces'. He and John Sex wheat-paste the Village with arcane sexual definitions culled from a vintage book. He subsequently creates a 'CLONES GO HOME' stencil and uses it to repel the invasion of conventional, Lacoste-wearing, mustachioed homosexuals, known at the time as 'clones'. Haring believes they should be confined to the West Village.

Eventually Haring begins to feel frustrated by his focus on 'word things'. If Mickey Mouse can symbolize an entire state, then who needs words? He decides to reimmerse himself in drawing, but it has to be drawing that leads to real communication. He can no longer be content with abstract shapes.

Haring produces a groundbreaking series of cartoony drawings depicting flying saucers (much of the conversation at the Nova Convention centred around space travel), bestial encounters between men and dogs, and men exposing their penises to all and sundry. These non-PG drawings are the primordial muck from which Haring's signature work will emerge.

Tony Shafrazi comes into Haring's life, hiring him as an assistant. The notorious gallerist – he is the former

enfant terrible who created headlines around the world when he vandalized Picasso's *Guernica* with spray-paint in the mid-1970s – is destined to play a big role in Haring's life. The positive stuff: as Shafrazi's assistant, Keith learns to do everything from pouring vino to wrapping art and writing press releases. The negative stuff: this experience provides Keith with a peek behind the curtain of the art-world establishment, and he does not like what he sees.

One of his first Shafrazi installs as a schlepper/assistant is for Keith Sonnier, a teacher at SVA and somebody he greatly admires. Haring's excitement evaporates when he experiences the opening party. All the kicky fun and jolly japes of Club 57 are missing. In their place Haring finds cynicism, effete posturing and blasé commentary. He is so devastated by the toxic atmosphere – even Sonnier looks insecure and unhappy – that he escapes to a stairwell and bursts into tears. There has to be more to making art than seeking the approval of a bitchy and elitist art world. Haring's commitment to bypassing the art establishment whenever possible is solidified.

When Haring's new drawings are exhibited at Club 57, Shafrazi drops by. Although impressed, he cannot imagine how any gallery owner might possibly shoehorn all that dog-fucking and penis-flashing into a gallery context.

In 1980, emboldened by the reaction to his dogs and spaceships, Keith decides to leave SVA. He feels that he has squeezed every last drop of education and inspiration out of it. According to Haring, Jeanne Siegel, the head of the Fine Arts department, gives him a thumbs up and a go-forth-and-create blessing. According to Jeanne, she did

not. Her recollection is that she advised him to stay and finish his studies.

Curating shows at Club 57 is inspiring but hardly remunerative. Haring falls back on menial jobs, including bike-messenger, sandwich-maker and Danceteria busboy. But he is not despondent. Far from it. His vision is coalescing. He is approached by Mudd Club manager Steve Maas to bring some creativity to his establishment. As the 1980s dawn, punk is losing steam. The cool of the Ramones is ceding to groovy, ironic performers like The Go-Go's and The Specials. The postmodern provocations of Club 57 are more in tune with the emerging culture. A delighted Keith is hired to curate shows at the Mudd Club's fourth-floor gallery.

Haring moves into a loft near seedy Times Square with Scharf. Keith's floor is pristine; Kenny's is chaotic. Drugs, smut and sleaze, circa 1980, provide the gritty backdrop for their cosy artistic ménage. Scharf and girlfriend Samantha McEwen offer emotional support to Keith, who is having boy trouble. His rakish merry-go-round of anonymous sex is proving to be less than emotionally fulfilling. Keith starts to look for love, but gets rejected by the lads who appeal to him most. He will have to wait until he is famous before he can attract the hunks of his desires.

4

Becoming a Thing

In July 1980, a group called Collaborative Projects, or COLAB, rents a large, crappy space on 42nd Street and Seventh Avenue and stages the *Times Square Show*. Haring, Basquiat and Scharf participate, alongside legit graffiti artists Lee Quiñones, Futura and Fab 5 Freddy. Haring befriends the graffiti superstars, especially Freddy, the future MTV host (you may well have heard his name rapped out by Debbie Harry in the Blondie song 'Rapture'). Hordes of groovy people attend the show. Basquiat rattles the cage of his fellow artists by incorporating the phrase 'FREE SEX' into the street-level signage. In this context – the sordid milieu of Times Square pre-Disneyfication – those words have as much power as any pictogram. The sign is quickly removed.

Graffiti was considered a serious problem at this time. The impulse to celebrate it, as opposed to spending millions to scrub it off the sides of buildings and trains, was rare. The *Times Square Show* was an important first step in connecting this street language with the art world and encouraging people to see it as a cultural phenomenon rather than a blight.

Man screws dog, again. In October 1980, Keith Haring's provocative drawings, including those depicting bestial

encounters, are exhibited at an open house at PS122 on 9th Street and First Avenue. The *SoHo News* writes a review and features the most arresting image from the show. Keith proudly shows this press clipping to his family, who go to great pains to ensure it is not seen by the neighbours or young Kristen. The Haring family impulse to censor the images – and their terror of allowing respectable folk to see them – attests to the power of symbols over words. A description of a man screwing a dog has very little impact, especially if you refuse to read it or you are illiterate. A simple pictogram, on the other hand, is lethal and unavoidable, and has the power to communicate with a broad spectrum of people, whether they like it or not. For Haring, communication is now paramount.

After the Times Square and PS122 shows, Haring feels genuine solidarity with the artist-outlaws of the graffiti community. The impulse to be part of something, which had driven him to become a Jesus Freak and then a substance abuser, propels him into the world of Freddy, Lee and Futura.

In the fall of 1980, Haring begins to communicate directly with the populace, using his growing repertoire of symbols. Armed with a giant Magic Marker, he brings his pictograms to public spaces, defacing advertising billboards and buildings with barking dogs and jumping figures, and eventually his crawling baby. He places his tags adjacent to those of other graffiti artists, initiating a dialogue with this secret society, a society that he will infiltrate and popularize, and to which he will forever be connected. What Jennie Livingston later did for voguing – her 1990 documentary

Paris Is Burning memorializing that art for the rest of eternity – Keith Haring will do for graffiti.

With the energy of graffiti culture pulsing in his veins, Haring proceeds onwards and downwards, into the bowels of the Manhattan subway. Here he spots the matt black panels that will play such a big role in the Haring progress. He runs back up to street level and buys a box of white chalk, then he heads back down to make art. It was a why-haven't-I-thought-of-this-before moment.

Back in the day, the Metropolitan Transportation Authority had a policy of covering expired subway advertising with a luscious matt black paper. When a billboard was ripped or tagged to death, or the advertiser's rental window expired, it behoved the overseers of the city's legendary public transport system to come up with a method of eliminating these eyesores, thereby rendering them enticing to future advertisers. Enter the era of the matt black paper. For Haring these dark rectangles with their porous surface – a chalkboard ripe for embellishment – were an open invitation to make art. Here was a way to create graffiti, but within the confines of the discreet rectangle or square.

Drew Straub and Kermit Oswald subsequently claimed that their pal Keith was inspired by their own previous chalk-drawing and defacement campaigns. Haring never specifically refutes this notion. Why would he? This was an era when inspiration flowed freely between individuals and groups. What is undeniable is that, from 1980 to 1985, Haring grabbed the chalk and ran with this concept, making it his own.

Leaping on and off trains, he is capable of executing between 30 and 40 drawings a day. Haring quickly notices that his guerrilla artworks are left largely untouched. This can be attributed to the fact that they appear less like hostile graffiti defacements and more like discreet, thoughtful, framed artworks: a pregnant woman dreams of a radiant baby; a tiny David yanks a sinister Goliath by a leash; a row of figures dance, their throbbing heads resembling snakes or hearts. The spontaneity of graffiti is combined with the traditions of poster art. In addition to creating new drawings Haring also begins to modify older ones, adding new symbols.

Haring is now communicating directly with his public. As Jeffrey Deitch would write in the catalogue for Haring's 1982 show: 'Masquerading as cartoons, they had thousands of subway riders a day studying sketches for Armageddon – drawings bubbling with unrestrained eroticism and spinning with signs of destruction.'

On 8 December 1980 John Lennon is assassinated in front of the Dakota apartment building, where he lives with Yoko Ono. Haring memorializes him by adding a new pictogram to his subway repertoire: the man with the hole in his stomach. He also begins to create drawings that comment critically or humorously on adjacent posters, such as a pile of bodies next to an Idi Amin movie poster. Tseng Kwong Chi, his photographer pal and Club 57 collaborator, begins to travel with Keith and document the hundreds of drawings. Eventually he will compile these into a book titled *Art in Transit*.

Subway riders often stop to chat with Haring while he draws. He looks for a concrete way to connect with this

growing fan base. He begins handing out free badges depicting radiant babies and barking dogs. This campaign is daringly self-promotional, something that is frowned upon in the art world. Surely success should arrive ineffably. It should not be a function of marketing strategy. Haring follows his instincts and charges ahead. The Haring badges quickly come to signify allegiance to the brave new world of art/style/fashion/music/downtown that is coalescing, and which Haring is helping to create.

April 1981. The Mudd Club erupts. Haring, aided and abetted by Fab 5 Freddy and Futura, curates *Beyond Words*, a momentous group show. 'Graffiti-based, rooted, inspired', reads the invite. The three-week run of the show creates a locus for the fragmented and competitive world of graffiti, revealing the majesty while also fuelling rivalries. The melding of street-art mavericks and gallery culture proves too much even for the anarchic Mudd Club. The club interior and then the entire neighbourhood gets tagged and retagged. Fights break out. Before long, the whole enterprise begins to slither out of control. Haring and the owner Steve Maas fall out over the mayhem. Haring quits.

This was to be his last job, but it may well have been his most meaningful. Keith Haring has elevated graffiti and created a whole new fan base. As Futura recalled, 'It wasn't Andy and it wasn't Jean-Michel. Keith was the catalyst.' Keith's street cred was established by this show. The Mudd Club show was also the place where he met the Rubells.

Don and Mera Rubell are legendary collectors who remain a vibrant force in the contemporary art world today. Playing the role of enthusiastic curator, Keith welcomes

them into the world of graffiti, subsequently taking them to meet the various artists. A few months later, Haring calls Don and Mera and invites them to a show of his own work at Club 57. They dig it. Don and Mera buy everything except for two pieces that have already been purchased by another art-world luminary and Haring-watcher, Jeffrey Deitch. Keith Haring is now a thing.

Fun fact: Don is the brother of Studio 54 creator Steve Rubell. During the late 1970s heyday of Studio 54 – think Bianca Jagger riding through the front door on a white horse – Steve and his partner Ian Schrager stashed thousands of dollars in the basement ceiling of this legendary disco, much to the chagrin of the tax inspector. Even ruthless lawyer Roy Cohn, a noted McCarthyite and early Trump associate, could not get them off the hook. In 1980, Rubell and Schrager are sentenced to three and a half years for tax evasion. They were released from jail on 17 April 1981, during the run of *Beyond Words*. Steve and Ian will eventually reincarnate themselves with the opening of the Palladium, a ferociously trendy club with a magnificent Haring dance-floor backdrop. Upon meeting Haring, Mera immediately saw parallels between her audacious brother-in-law Steve and artist Keith: 'Both had that same energy and that love of public, love of young talent, love of the street, love of the urban experience! And the love of the night, the music, the freedom, the sexuality!'

Becoming a thing is complex and has an immediate impact on Haring's various relationships. It precipitates an excruciating period during which Kenny Scharf was forced to endure the ordeal of watching collectors like the

Rubells trotting blithely past his work in order to purchase drawings created by his loftmate. This caused fractures in their relationship. It also ended up lighting a fire under Scharf. It forced him to stop comparing his progress with that of Haring, and to seek his own path to glory.

Becoming a thing gives Keith a confidence that has a major impact on his love life. In 1981, swanning around the Club Baths in his skimpy white towel, Keith meets an attractive, slim, Black dude named Juan Dubose. They set up home in a tent, in an apartment shared with Samantha McEwen, Scharf's now ex-girlfriend. Juan's day job is repairing and installing car stereos. He brings home audio equipment and fills the pad with funky sounds. Juan is also a great cook. Haring turns the basement into a studio. They create a happy ménage.

At this time Haring also forms a paternal relationship with a mega-talented 14-year-old pint-sized graffiti artist called LA II, real name Angel Ortiz. They collaborate, embellishing found objects with their respective tags. One piece sells for $1,400. Keith splits the dough. When LA II's mother finds out about this unconventional liaison, she invites Keith to dinner to verify that nothing shady or exploitative is going on. Mrs Ortiz takes to Keith and gives the working friendship her blessing. Keith begins to hang out with LA II and all his friends. He enjoys the experience but says he 'felt like a cub-scout leader'.

Becoming a thing is stressful. The growing entourage of young artists and the haggling art collectors who descend on his studio are starting to make him nuts. Is it time to surrender, sign on with a gallery and let some

big-shot owner do all the hondling? He still feels strongly that tying himself to a gallery in the conventional manner will corrupt him. It was only a year and a half earlier that he was sobbing on Shafrazi's stairwell at the Sonnier opening. Keith continues collaborating with LA II, working on his subway campaign and selling his art himself.

Becoming a thing means that the cognoscenti come to the studio to kiss Keith's ring. Enter the late, great Henry Geldzahler, NYC's Commissioner of Culture. After spending time with Haring, and making a few purchases, he returns to his office, where he rallies the entire staff of 60 people and harangues them about the 23-year-old he has just met. He shows them the drawings he has purchased and gives them a run-don't-walk mandate to invest in Haring. Considering that his boss, Mayor Koch, was in the midst of waging a state-wide war on graffiti, this was a brave move.

Becoming a thing can be surreal. On a cold day in January 1982, Keith is drawing at the subway station on Seventh Avenue and 51st Street when he is nabbed by the police. They lock him in a fetid public bathroom to await the patrol car that will take him to the 59th Street Precinct. In addition to being grossed out, Haring is also petrified. Once at the station he is introduced as the guy who does all those chalk drawings on the subway and is given a hero's welcome. After the fan worship subsides, he receives the usual summons.

5

Showtime

Marilyn Monroe once observed that she did not really grasp the idea that she had become a 'star' until one day, driving a friend to the airport in LA, she saw her name on a movie marquee. When Haring saw his work blazing in lights at the crossroads of the world in Times Square, did he have his Marilyn moment?

In February 1982, Haring gets his name in lights or, more specifically, his now increasingly famous pictograms. With the help of sponsorship from New York's Public Art Fund, a company called Spectacolor creates a 30-second animation of Haring's symbols and displays them on a giant illuminated billboard in Times Square. Haring's oeuvre shimmers and flashes continuously for the entire month, exposing millions to animated radiant babies, barking dogs and stomachless figures.

The 1980s are starting to swing, and Haring has demonstrated that he has the makings of an art star. But his aversion to the art establishment has set him on a mission to rewrite the rule book, especially the commercial side of his business. He begins to test the waters. In addition to selling his work out of his own studio, he tentatively places a few pieces with various galleries. Tony Shafrazi, with a new gallery just opened on Mercer Street in SoHo,

is in need of a crown jewel. He sets about wooing his former schlepper.

Although Haring trusts his former employer, the *Guernica* crime still sticks in his craw. After much soul-searching, Haring concedes that Shafrazi's vandalistic act had the best of radical intentions. His goal was to reconnect the viewer with the horrors of war – the Vietnam War in particular – thereby restoring the work to its original purpose. Haring relents and signs on with Shafrazi in spring 1982. A date is set for an October show.

In June, Haring creates an anti-nuclear image, a radiant baby engulfed by a mushroom cloud, whirring nuclei and warring factions. Using his own money, he prints 20,000 posters. He and his pals hand them out to demonstrators at a historic anti-nuclear rally in Central Park. As with his subway badges, there is no charge. The depth of his commitment to the anti-nuclear cause is unclear. One thing is for sure: he understands image and opportunity. He courts eyeballs. The Armageddon theme, and the massive number of attendees, fit perfectly with Haring's mission to infiltrate and communicate.

One month later Haring and boyfriend Juan Dubose collaborate on a mural at Houston and Bowery. Embellishing this massive derelict wall is a continuation of the colonizing impulse that began in his art school years, when every closet or hallway was grist to his brush. Dubose and Haring laboriously rid the vacant lot of appalling amounts of trash, carting off 40 or 50 bags by Haring's count. They then set about painting a fluorescent combo of breakdancing figures and black-on-hot-pink three-eyed faces. The three-eyed

faces – a recent addition to the Haring canon – had come about by accident during the installation of a group show the previous Halloween. The birth of the three-eyed face is very Haring-esque and merits further examination.

On the occasion of the birth of the three-eyed face, Haring was recovering from an acid trip. The day after taking LSD, he often experienced an unusual level of mental clarity. On this occasion he was painting directly onto the wall of the Annina Nosei Gallery. In his crisp, post-hallucinogenic state he decided to reduce Mickey Mouse down to his eyeballs. He painted a frame, followed by one oversized eyeball. Haring saw immediately that he had misjudged the placement. The only way to rectify the situation was to add a third eye. His favourite Louis Pasteur quote – 'Chance only favours the prepared mind' – seems apposite. His mind had been prepped by a hallucinogen, and was waiting to be favoured by the accidentally mis-placed eyeball.

Back to the Houston Street mural: with its giant three-eyed faces, painted on a shocking-pink ground, this artwork is a perk-up-the-neighbourhood, art-for-the-people moment. Although the 'people' may well have loved it, the downtown artist community decidedly does not. Haring is forced to endure a protracted backlash, a magnification of the hostility that caused fellow students to tear down his drawings in the hallways at SVA. Resentful East Village artists, eager to accuse Haring of being a sell-out, deface the mural with buckets of paint and bitchy comments. It is a Twitter backlash writ large, four decades before Twitter backlashes. And it gets worse. In a *Village Voice* interview, Haring

had blithely mentioned that he had yet to sell a painting for more than $10,000 (with echoes of supermodel Linda Evangelista's infamous 1990s comment about not getting out of bed for less than $10,000 per day). This inspires a vandal to cover the entire mural with a massive $9,999. Hurt and irate, Haring obliterates this entire artwork with silver paint and vows never to do another mural in the East Village. Haring's success has awakened an ugly green-eyed monster, the inevitable downside of becoming a thing.

October 1982. The Shafrazi debut is looming. Time to get his butt in gear. Haring has retained his aversion to canvas, still finding it conventional, uninspiring and psychologically blocking. So what materials shall he use? Large swathes of seamless paper are unwieldy and do not scream 'investment'. They are therefore unappealing to potential collectors. Watching construction workers in the street, Keith is intrigued by their durable, coloured vinyl tarps. He finds a supplier in Brooklyn and orders a whole bunch, specifying colours – mostly yellow and bright red – and the spacing of the grommets.

What medium should he use? Experimentation follows. The only paint that will take root on this impermeable surface – Haring uses the word 'bite' – is a type of silkscreening ink, diluted with toxic thinner, which ever-so-slightly eats its way into the surface of the tarp.

The resulting 12-foot-square surfaces – giant drippy patterns and pictograms in a variety of colour combos – are the principal players in this first show. All the other pieces – abundant drawings and metal-baked enamel pieces – are hung salon-style, surrounding the tarps, with confidence

and precision. A 13-foot-square tarp featuring two dancing figures and a giant heart fits perfectly onto the focal wall. Blank spaces are filled in with breaking figures painted directly onto any remaining wall space. A continuous Morse code of red dashes zips along the entire baseboard. With this meticulously designed installation, Haring has set a precedent that will carry forth throughout his career: he is the master of the total installation. Every possible surface is considered and addressed. Even the basement.

Lurking in the Shafrazi basement is a black-light installation consisting of Day-Glo paintings and three-dimensional collaborative objects, such as a Statue of Liberty and a Copenhagen Little Mermaid. LA II and Haring have evolved a working relationship: LA II's tags and embellishments add a dense, all-over pattern that gives electricity and graffiti-cred to Haring's symbols.

The installation and opening are featured on the CBS evening news. At the time Dan Rather is the top-rated news anchor in the USA. Haring's frantic preparations and star-studded opening are seen by approximately 18 million viewers, as compared with today, where the fragmented media landscape gives CBS news a nightly viewership of barely 5 million.

The opening brings together the club scene, the graffiti scene and a gaggle of established artists, including Rauschenberg, Richard Serra, Francesco Clemente and Roy Lichtenstein. Coca-Cola is served in small bottles. The high/low mix brings joy to the occasion and avoids the sourness that traumatized Haring at the Sonnier opening. Into the mayhem arrive the Harings of Kutztown. The

bewildered family are spotted by collector Mera Rubell, who spirits them uptown and feeds them spaghetti.

Before the World Wide Web, galleries relied on catalogues to spread the word. Haring and Shafrazi create a swanky catalogue and share the $40,000 cost (individual copies now change hands on eBay for over $1,000). Adorned with a three-eyed face, this book contains essays by Jeffrey Deitch and Robert Pincus-Witten, plus photographs by Kwong Chi. The massive outlay pays off. The catalogue helps establish Keith globally as the new Warhol, an emissary of US pop bravado. As Deitch explains in his catalogue essay: 'Haring is one of the few artists since the pop era who has been able to successfully integrate America's great commercial art form – cartooning – into fine art.'

On Saturday 13 November Andy Warhol, babbling in his diaries, records that he attended a closing party at Shafrazi, noting that the event was filled with Keith's Black and Latino entourage. He smugly notes that he avoided the black-light, Day-Glo basement, knowing that it would make a spectacle out of his white fright wig. The two artists have yet to meet properly. That auspicious encounter takes place early the following year.

On 3 February 1983 Warhol pays $4 to cab it over to the Lower East Side for a Haring opening at the Fun Gallery. This space is the locus of the whole new cultural movement that is erupting around breakdancing, style and graffiti. The soundtrack of this scene is DJ-scratching, hissing spray-paint cans and early hip-hop. Haring has just come off his Shafrazi show, where most of the works sold. Although he has no pressing need for a show at the marginal Fun

Gallery, his instincts tell him that it's the right moment and the right place.

The memorable installation captures the zeitgeist. He and LA II cover the gallery walls in gummy bear-coloured, spray-painted worms and figures and tags. The works consist of large leather hides – tagged and graffitied – and giant Smurfs, which are covered in small tags, symbols and doodles. The leather hides are sourced for Haring by his new pal Bobby Breslau. Bobby used to design handbags for Halston, hence his familiarity with the leather wholesalers of Manhattan. He knows everyone on earth, including Warhol. Haring describes him as 'my Jewish mother'.

Warhol arrives. They chat. Keith is nervous. He is meeting his idol face to face. In his diaries Andy makes positive comments about the show, suggesting that Keith's installation – the graffiti-covered walls with the works hanging on top – refers back to his own legendary Whitney show, where he hung his artworks against a background of his cow-print wallpaper. Warhol is handing a baton to Keith, but making sure the world knows that it's a Warhol baton.

The Fun Gallery meeting is the beginning of the Warhol/Haring relationship. Warhol and Haring exchange art, chat on the phone, and socialize at Keith and Juan's house parties and elsewhere. Warhol makes a portrait of Juan and Keith. Keith and Andy form a triad with Madonna.

Madonna is performing regularly at the Roxy, centre of the breakdancing and hip-hop scene, and with her handsome producer-boyfriend Jellybean Benitez, she adds scrappy glamour to the Fun Gallery/East Village scene. Andy, Keith and Madonna become the pillars of a new cultural elite.

In John Gruen's authorized Haring biography, Madonna shares at length her love and admiration for Keith. She feels that she and Keith have much in common. They are both driven, creative artists with a pop sensibility who have become successful, and as a result are subject to envy and accusations that they are selling out. They are both immersed in a new downtown culture that they are helping to create. As noted in my introduction, they are attracted to the same genre of dude.

Aided by the Shafrazi catalogue, vibrations from this new scene spread across the pond. Keith begins his European conquest. He travels to Germany, the Netherlands and Belgium. In Italy he exhibits at the Galleria Lucio Amelio. On 23 March 1983 Warhol notes in his diary that Haring is so famous and fabulous that he flew from Japan to New York for three days, and thence to Paris.

The new globe-trotting Haring makes sure his travel schedule permits him to be back in New York City in order to shimmy all night at Paradise Garage, a legendary disco that operated from 1977 to 1987 and is generally acknowledged to be the birthplace of house music. Saturday nights, gay night at the Gay-rage, are like a religious communal ritual for Haring and Dubose: music by Larry Levan, no alcohol, just the transcendence of being among a sweating throng of mostly Black and Latino street kids. No talking, just dancing.

The place was exceptionally poorly ventilated. (I can personally attest to this. Whenever I hear 'You Make Me Feel (Mighty Real)' by Sylvester, I am right back at 84 King Street, wondering if I am going to pass out.) Attendees dealt with this issue by discarding garments or simply showing

up in shorts and tanks. The sea of dancing bodies – some popping and locking – resembled a Haring drawing come to life. Haring is so inspired by the place that he creates an installation, a complicated drawing using Japanese sumi ink. He is miffed when the crowd continues gyrating, oblivious to his artwork. Despite this random slice of disco philistinism, Haring's passion for Paradise Garage remains undimmed.

In August 1983 something terrible and unexpected happens, sending a shiver through bohemia: performance artist Klaus Nomi dies. The mysterious disease – 'Gay Cancer' – which has been felling gay men on both coasts, has breached Haring's world. Previously thought to be of concern only to the Levi-wearing Village people – the clones – over on Christopher Street, this disease has crossed over to the East Village and killed a habitué of Club 57.

6

Bill and Grace

Keith Haring dove into the creative, multicultural lagoon that was, and is, New York City, finding an abundance of artistic inspiration and emotional connection. Race becomes a central theme in his life and work. Those of us who recall Haring from this era will remember a guy with a bulging Black and Latino entourage. Since encountering the cultural mores of his African American co-workers at the Pittsburgh Arts and Crafts Center, Haring's empathy for non-white persons has grown. Haring's enthusiasm – he is a culturally curious dude – is entirely understandable. There is much to be excited about. By the 1980s the offspring of Generation Civil Rights are gaining in visibility and participating in the creation of new threads in popular culture – art, funk, hip-hop, disco, style – and Keith is an avid supporter and consumer. Yes, there is a sexual component to his infatuation, but Haring maintains that there is no better way to experience and empathize than by having a sexual relationship, thereby 'becoming' the desired person.

Haring may be hanging in the hood, but he is also building a global network of prestigious collaborators. While in the UK he consorts with William Burroughs. He also creates fabric designs with UK fashion mavericks

Malcolm McLaren and Vivienne Westwood. Most importantly, he exhibits at the infamous Robert Fraser Gallery.

Fraser, or Groovy Bob as this Old Etonian is known to his pals, was one of the principal architects of Swinging London. In the 1960s he championed many unconventional talents, including Warhol, Bridget Riley, Jim Dine and Ed Ruscha. He was instrumental in introducing Peter Blake to The Beatles, a collaboration that resulted in the *Sgt. Pepper* album cover. Like Shafrazi, he has had a highly publicized brush with the law. In 1967 he was sent to jail after the notorious Redlands bust, which also involved Keith Richards, Marianne Faithfull and Mick Jagger. After Fraser and Jagger were hauled off to prison, pop artist Richard Hamilton memorialized the occasion with an artwork that has now become iconic: Jagger and Fraser, in the back of a car, are depicted raising their handcuffed wrists, a half-hearted attempt to conceal their identity from press photographers. The piece is titled *Swingeing London*, after the swingeing (excessive) sentence that was handed down.

Shafrazi had previously been in awe of Fraser, the 1960s icon. Now the tables are turned and Fraser is courting Shafrazi, a man who he sees, accurately, as the conduit to the New York graffiti-inspired scene. Shafrazi's new crop of *enfants terribles* allow Fraser to reprise his role of establishment rule-breaker. Fraser's 1983 Haring show brought graffiti, irreverence, breakdancing and boom boxes to the stuffy Cork Street milieu.

While frolicking in the UK, Haring reconnects with a beautiful Black dancer named Bill T. Jones. Their collision in London is destined to create a milestone in both their careers.

Bill T. Jones was born the tenth of twelve children in Florida in 1952. His parents were migrant farm labourers. He attended Binghamton University for underprivileged students, studying ballet and modern dance. During his 1971 freshman year, he met and fell in love with Arnie Zane, a graduate who was pulling together a career as a photographer. Their personal and professional relationship led to the formation in 1982 of the Bill T. Jones/Arnie Zane Dance Company. When I moved to NYC, the names Bill T. Jones and Arnie Zane were tossed around with nonchalant regularity. They were to modern dance what Haring and Scharf were to the new art scene.

Haring and Jones have met before, collaborating a few months earlier at the Kitchen, an experimental theatre space in SoHo. Keith drew while Bill danced. The performance, titled *Long Distance*, can be viewed on YouTube. Be sure to turn up the volume. The soundtrack comprises Keith's brush and Bill's feet. According to Bill, 'the piece produced an intimacy between us that I prized'.

In England they collaborate again, with increasing intimacy, producing what will become some of the most famous Haring images. Haring has recently begun to experiment with body-painting. He painted the body of a student for an Italian magazine while in Naples for his show at the Galleria Lucio Amelio. In London Keith rents a space. Bill disrobes. For the next four hours Keith paints Bill T. Jones's naked body. That magnificent dancer physique provides a miraculous canvas. Arnie Zane video-tapes, Kwong Chi takes pictures. This collaboration is an endurance test for Jones. Hangers-on are gawping. The paint is cold. When Bill moves, the paint cracks, but in a good

way. By the time Keith adds the last three lines to Jones's penis, both men feel a sense of communion.

At the time Haring paints Bill T. Jones, the concept of tribal beauty is very much in the zeitgeist. The resulting images, the Black male body covered in tribal, slightly cracking markings, recall the photos of Leni Riefenstahl that were doing the rounds at the time. In the 1970s, Riefenstahl – she was attempting to erase the memory of her association with Hitler and the Third Reich, and reinvent herself as an anthropological documentarian – published her photographs of Nuba men, adorned with ceremonial body-paint. Her book *The People of Kau* sat on the coffee tables of many culture vultures during the 1970s and '80s. The images of beautiful young Black tribesmen adorned with bold graphic designs on their faces and bodies are unforgettable.

Bill T. Jones was very clear about the terms of this collaboration. He wisely anticipated the possibility that all the credit might subsequently go to Haring and that he, 'the canvas', might gradually become anonymous and be expunged from art history. He insisted that whenever the images are published, his name must also appear. During his lifetime Haring honoured this agreement. Today the Bill images sometimes appear on social media without a Bill T. Jones credit. I encourage readers to make corrective comments wherever possible.

Jones and Haring have a complex relationship. They are both gay men, artists, involved in interracial relationships, Keith with Juan, and Bill with the talented, white, middle-class, Jewish Italian Arnie. Bill voices concerns to Keith.

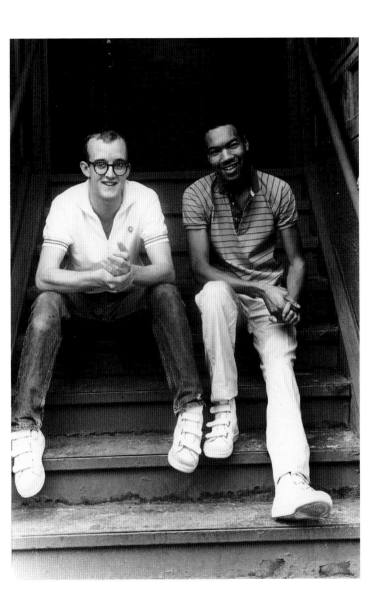

Haring with Juan Dubose, his first long-term boyfriend, 1983.

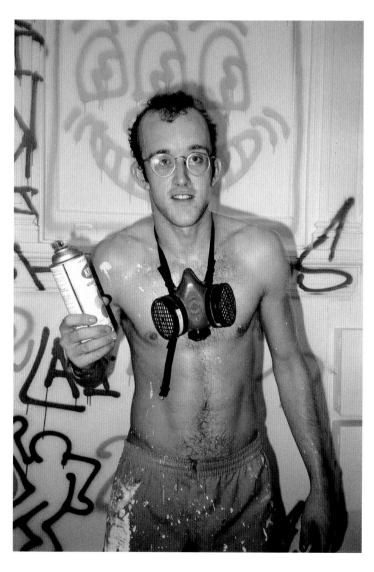

In full graffiti mode, Haring slams and tags
with his trusty Krylon 'cannon', 1984.

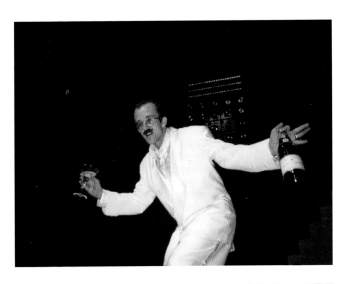

TOP – Birthday boy Haring hosts his second Party of Life,
this time at the Palladium in New York, 1985.

ABOVE – Haring arrives at the official opening of the Palladium
in a Stephen Sprouse-designed fluorescent suit, 1985.

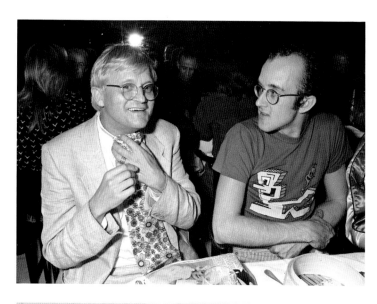

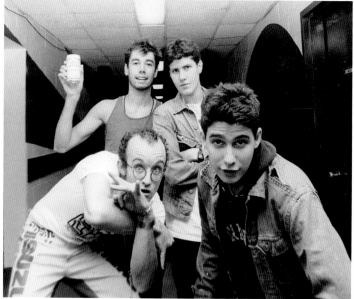

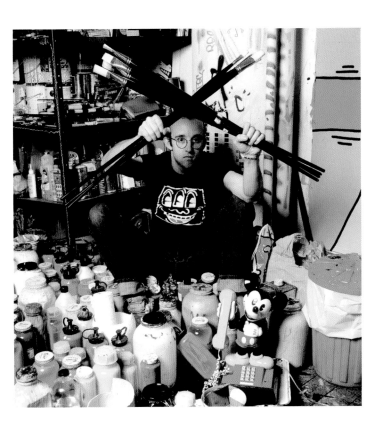

OPPOSITE, TOP – Haring hangs with Hockney at Mr Chow in New York, 1985.

OPPOSITE, BOTTOM – Cavorting with the Beastie Boys
at Madison Square Garden, 1985.

ABOVE – Strike a pose: Haring in his studio, 1985.

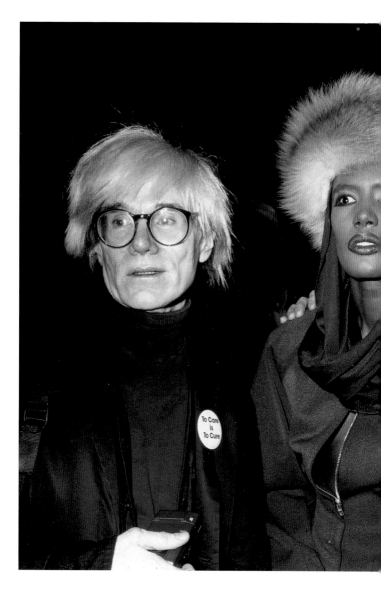

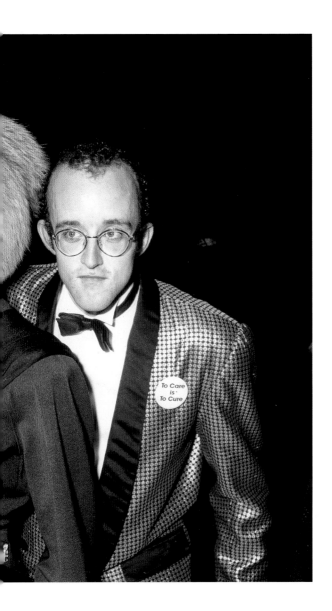

On the button: To Care is To Cure

Warhol, Grace Jones and Haring add their celebrity wattage
to an amfAR benefit in New York, 1985.

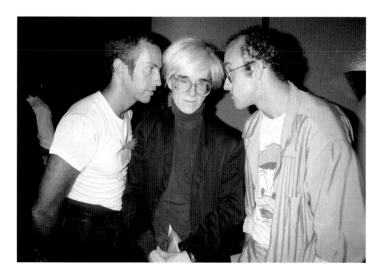

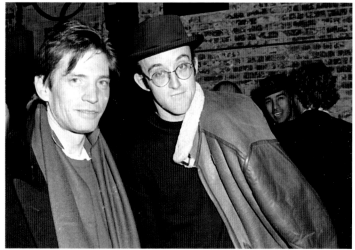

TOP – Kenny Scharf and Haring flank Warhol at New York 'It Girl'
Elizabeth Saltzman's birthday party, 1986.

ABOVE – Robert Mapplethorpe and Haring at the Tunnel in New York City, 1986.
Juan Rivera, Haring's second long-term boyfriend, smiles in the background.

TOP – Haring and supermodel Iman posing at
Grace Jones's party in Paris, 1986.

ABOVE – Jean-Michel Basquiat DJs at the Area club, at the opening party
for Haring's Pop Shop, 1986. Artist Francesco Clemente sits to his right.

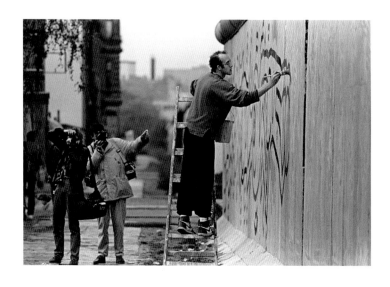

Haring paints a 300-metre mural on the Berlin Wall, 1986.

Haring poses on top of one of his painted metal sculptures outside the
United Nations building in New York, 1986.

Party time in New York: Haring with fellow Club 57 alumni
Ann Magnuson and Kenny Scharf, 1987.

TOP – Haring prepares to repaint his iconic 'Crack is Wack' mural after it was vandalized with the words 'Crack is it'. Parks Commissioner Henry J. Stern offers encouragement.

ABOVE – Haring and Brooke Shields at the Palladium, 1987. The two became friendly after collaborating on a poster shot by Richard Avedon.

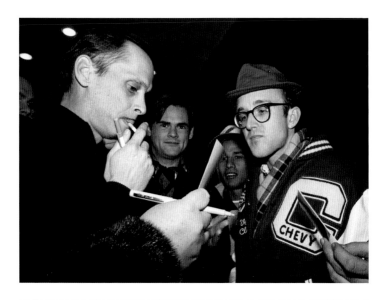

TOP – Haring fêtes director John Waters at the opening of *Hairspray*, 1988.
Juan Rivera stands on Haring's right.

ABOVE – Haring draws on a stone lithography block in Paris, 1989.

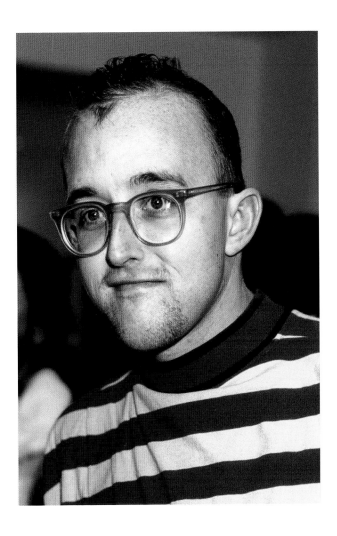

Haring puts on a brave face in Paris, a month
before his death on 16 February 1990.

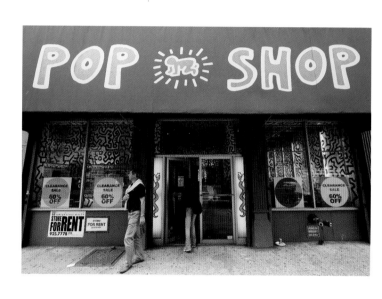

After 20 years in business, Haring's Pop Shop on New York's
Lafayette Street finally closed its doors in 2005.

He feels that, in Zane, he has somebody with whom he can share and collaborate, artist to artist. Bill cautions Keith, suggesting that he has chosen a relationship with a significant power imbalance, and that making it work, figuring out how to 'bring that person through his emotional perils and feelings of inadequacy', is a big responsibility. Was Keith ready?

The Bill T. Jones/Haring collaboration provides the most memorable visuals in Haring's second show at Shafrazi, titled *Into '84*. The large photographs are juxtaposed with wooden painted sculptures, a Kermit collaboration. Haring's Kutztown pal Kermit is now living in Greenpoint, Brooklyn, and making frames for a living. He and Haring construct a series of large black wooden totems. Using a router, Haring and Kermit gouge Haring's symbols and lines into the vertical surfaces of these sculptures. These patterns are emphasized with red and yellow paint. The finished sculptures are then placed throughout the gallery on a chequerboard floor.

Haring paints the walls of the gallery with red and white abstract dotted shapes. The painted walls form a backdrop for the Bill T. Jones photographs. Once again Haring has created a complete floor-to-ceiling installation. And once again there is a black-light hangout. For the run of this exhibit, Shafrazi rents an adjacent basement, which Haring and LA II transform with fluorescent paint and spray-painted graffiti. Juan Dubose brings in stereo equipment. The Day-Glo den hosts a month-long breakdancing bacchanal. When Andy wanders innocently down into Shafrazi's basement, his wig begins to glow.

Out of respect, nobody says anything. Then the poet Rene Ricard begins shrieking, 'Your hair! It's glowing! Your hair, it's incredible!' According to Haring, Andy was traumatized and avoided black light forever after.

Haring is 25 years old and already a *grand seigneur* with a significant brood of courtiers, assistants and hangers-on. His impulse to collaborate necessitates sensitive negotiations with multiple individuals who are reliant on the income they receive as a result of their affiliation with Haring. There are mouths to feed, collaborators to be compensated. There are also feelings to be assuaged. Who is unhappy today? Who feels slighted? Who wants more $$? His growing entourage mirrors that of his mentor Warhol, who was both loved and hated by the denizens of his Factory.

Andy plays an increasingly important role in Haring's life. Haring's name pops up with growing regularity in the Warhol diaries. When Haring, who is now on a body-painting roll, declares his desire to paint the body of Grace Jones, it is Andy who makes it happen.

Grace Jones, the queen of Black androgyny, is the Ziggy Stardust of the 1980s. With her frightening beauty, her uncompromising style and her no-fucks-given attitude, she is a beacon for all those who celebrate outsider glamour. She is not just the disco queen of the Paradise Garage, she is also hip and brilliantly art-directed. Haring idolizes her. He feels she is the ultimate combo of primitive and pop. This is a very meaningful crossover for him. Whereas Bill T. Jones comes from the highbrow world of performance and modern dance, Grace has broken through into pop stardom.

She is a cartoon superhero who wears catsuits and carries a whip and commands hordes of adoring acolytes to do her bidding, and that's before she has even mounted the stage. Haring is dying to paint her body.

Andy decides to profile Grace in his celeb magazine *Interview*. Highlighting the Haring/Bill T. Jones collaboration, Warhol persuades Grace to submit her flesh to Haring's brush. He then hires Robert Mapplethorpe to take the pictures. Artist/designer David Spada is commissioned to create a brassiere, a crown and a hula skirt.

Grace has a reputation for volatility and lateness. It is part of her appeal. I personally recall twiddling my thumbs at more than one Grace concert in the 1980s, including one at Lion Country Safari in California, where it felt like she arrived on the following day. At the Mapplethorpe shoot Grace does not disappoint. True to form, Haring and Mapplethorpe are kept waiting for two hours. Then Grace arrives, on a motorcycle. She disrobes and calmly submits to Haring's vision.

The session is a triumph. Wearing Spada's extraordinary outfit, including a towering headpiece, Grace strikes Haring-esque attitudes. After the shoot Grace leaves without removing the body-paint. She jumps on her motorcycle and roars off into the night. Coincidentally Haring is invited to the same party that evening. His mind is blown as he watches the still-painted Jones make her entrance.

In 1984 Haring's career passes a tipping point. He travels, he paints, he murals, he exhibits, he rushes back to New York City to gyrate at Paradise Garage, and then he travels and paints some more. One minute he is at the

Le Mans racetrack, painting on the chassis of a racing car, the next he is embellishing fishermen's cottages in Brazil. He paints murals in Australia, Europe and the USA. Somehow he manages to pull off three artist-in-residence programmes.

On 16 May Haring celebrates his 26th birthday with an event he dubs the Party of Life at Paradise Garage. The beneficent Haring is making good money and wants to spread the love. He hires LA II to help decorate. The DJs are Larry Levan and Juan Dubose. Designer *du jour* Stephen Sprouse dresses Haring and his immediate pals in his fluorescent suitings. Spada makes Day-Glo necklaces. Three thousand people show up, including Diana Ross, Halston, Matt Dillon and Steve Rubell. Madonna arrives wearing a Haring-painted jacket and later performs 'Dress You Up' and 'Like a Virgin'. The invite, a printed handkerchief, remains a collectable item to this day. Contemporary event planners at Art Basel – who dream of creating this kind of organic cultural sizzle – must surely feel suicidal when they read about the Party of Life.

This event was a cultural touchstone, but it was also an unabashed self-celebration. This is the magic of Haring. He manages to simultaneously celebrate himself – spotlight on Keith! – while also appearing, and being, generous and benevolent. One suspects his desire to be fêted and acknowledged was equally matched by his desire to share.

Keith is benevolent, but he is also horny. Around this time Keith starts hanging out at a hustler bar called the Phoenix, which features jockstrap-wearing breakdancers. He begins cheating on Juan Dubose. He is now surrounded

by good-looking lads, the kinds of hotties who would have rejected or ignored him before he hit the big time. When he travels he is treated like a visiting potentate. Temptation is everywhere. Power is an aphrodisiac and Haring is now the alpha.

His ascension is accompanied by an increase in criticism. In Australia he faces accusations of cultural appropriation. He paints a mural at the National Gallery of Victoria in Melbourne, working directly on a massive glass façade. The reception is not entirely positive. Aussie newspapers accuse him of knocking off Aboriginal art. A drive-by shooter sends a bullet through the glass. Now that Haring is rich, and pally with Warhol, he can cry all the way to the bank and later discuss his trials and tribulations over dinner at Mr Chow with fellow artists, of whom there are a growing number.

The vibrancy of the 1980s throws up a massive number of artists like Haring and Basquiat. Back then it was still cheap to live in New York City. Aspirants were decamping to the Village every day from their hometowns. The art establishment observes this new crop with wariness. Unsure of how to sort the wheat from the chaff – who has more staying power, Baechler, Cutrone, Scharf or Haring? – the museums sit on the sidelines and wait to see how things play out.

Haring is in an odd position. Having boldly bypassed the establishment, he now finds himself wondering why the establishment is not banging down his door. The glee he feels at having avoided the corrupting influence of the conventional route is tinged with a little uncertainty.

He is like a popular, naughty debutante: although her dance-card is full of admirers, she finds herself going through the names of her suitors and discovering a dearth of dukes and earls.

7

The Gold Tuxedo

Haring has achieved bohemian, fashionable, cultural cred. People are queuing up to buy his work and invite him to fancy dinners. He is successful by any measure, but he wants more. He wants the big museums to sit up and take notice.

In 1985 Haring and Shafrazi mount a double-barrelled assault on the art world. Haring will unveil two simultaneous gallery shows in New York City, a Shafrazi one-man show (his third) and, just around the corner, a sculpture show at the storied Leo Castelli Gallery. A poster advertising both exhibits is created. Haring is photographed in the shadow of a massive steel barking dog. Much has changed in his life, but his facial expression – inscrutable, nerdy, remote, and ever so slightly surprised – has remained remarkably consistent. Postcards bearing this image and promoting both exhibits plop into the mailboxes of the New York arterati.

For the Shafrazi show Haring overcomes his aversion to stretched canvas. He is no longer intimidated either by the conventional nature of canvas or by the cost. He is also anxious to move on from the foul-smelling toxic paints that he has been obliged to use when painting on plastic tarps.

Some of the new canvases are circular, an expensive option, but Haring can now afford it. He creates large colourful acrylic paintings, accentuated with black oil-painted outlines. The signature Haring playfulness is juxtaposed with weightier subject matter. Social justice themes include AIDS awareness and police brutality. Haring depicts Michael Stewart, a young African American artist of his acquaintance, who met a brutal end after being nabbed on the subway for drug possession, and taken into police custody.

Meanwhile, around the corner at 142 Greene Street, Haring enters what he describes as 'a holy place'. Leo Castelli has exhibited the greats, including James Rosenquist, Jasper Johns and Roy Lichtenstein. Castelli compares Haring favourably to the latter – both Haring and Lichtenstein are inspired by cartoons. However, while Lichtenstein took his Pop imagery directly from the funnies, Haring, the new kid on the block, has given birth to his very own cartoon vocabulary.

After making small aluminium models, Haring travels to the Lippincott Foundry in Connecticut, where he oversees the forging and welding of the final pieces. These oversized versions of his now iconic symbols and dancing figures are painted with primary colours, catapulting the viewer into a children's playground.

Once the sculptures are installed, Haring, as is his wont, sets about turning the gallery space into a total environment. He blows Castelli's mind by painting, in one day, a dancing, throbbing mural of cheering spectators and animals around the interior perimeter of the gallery.

Haring revels in the honour of his Castelli debut, but also makes sure to counter any whiff of adult pomposity. During the run of the show, hordes of schoolkids are invited to invade the gallery, clamber on the sculptures and meet the artist.

Another prestigious gig quickly follows: in December 1985, a month after his Shafrazi/Castelli takeover in NYC, Haring is celebrated by the Bordeaux Museum of Contemporary Art in France with a one-man show. Paintings and drawings going back to 1980 are installed in the various galleries. The *pièce de résistance* is a site-specific mural painted on ten canvases and installed, back to back, within five massive architectural arches. In the run-up to the Bordeaux show Haring, uncharacteristically, finds himself at a loss for content. What to do with these ten monumental pointy Gothic surfaces?

On the Saturday night preceding his trip to France, Haring is to be found, as usual, unleashing his id at the Paradise Garage. He is pondering the Bordeaux project when, suddenly, an idea comes to him: ten paintings, ten commandments. He spends the rest of the evening trying to recall his ten thou shalts and shalt nots. Upon arrival in Bordeaux he asks for a Bible, and gulps down a few amphetamines. The resulting paintings are some of my personal favourites and make me wish Haring had taken on more classic themes during his short lifetime.

Haring wears a gold lamé tux to the opening. One wonders if, checking himself out in the hotel mirror, he flashes back on the teenage horror of being forced to wear his uncle's threadbare hand-me-down pants. Noteworthy

attendees include Patrick Kelly, Andrée Putman, George Condo, Brion Gysin, Jeffrey Deitch and Helmut Newton. The following day there is a luncheon at a nearby Rothschild château. Keith is now living a life of elite bohemian glamour, and loving it. Although he never turns his back on 'the people', his infatuation with fabulosity is undeniable.

Polaroids from this time show Haring posing with everyone from Jean Paul Gaultier to JFK Jr., Brooke Shields and La Toya Jackson. Earlier in 1985, Haring attends the celebrity event of the year: Madonna's West Coast wedding to Sean Penn. As paparazzi-filled helicopters circle overhead – drowning out the ceremony – Haring and Warhol mingle with Dolly Parton and Cher, among others. Haring is a bold-faced name among bold-faced names.

When Steve Rubell and Ian Schrager open the Palladium on 14th Street – this updated, artsy version of Studio 54 is huge news – Haring is commissioned to paint the backdrop for the dance floor. Scharf, Clemente, Basquiat and Mike Todd all create installations in other parts of the club. The opening on 15 May is a perfect mash-up of art, style, fashion and celebrity. One week later, on 22 May, Haring stages his second Party of Life at the Palladium, inviting 5,000 people and closing traffic on 14th Street. Boy George sings 'Happy Birthday'. Bianca Jagger arrives, not on a white horse, but with a white cast on her leg. Haring meets a hot dude and has sex in a bathroom stall while pals peek over the partition, catcall and take pictures.

Haring is unwittingly creating the prototype for future artists like Damien Hirst or Tracey Emin. In order to hit the big time, the late twentieth-century artist must

be comfortable with the role of 'fabulous person'. It's not enough to be taken seriously; you also have to be an image-conscious individual with social wattage who can head confidently to galas and art fairs, play the role of star and swan about.

Yes, Haring has become a very trendy, glamorous guy, but he also remains passionate about his mind, and the cultivation thereof. In 1985 he acquires yet another guru. When Haring once again paints Grace Jones's body, this time for performances at the Paradise Garage, she introduces him to her friend Timothy Leary, the 1960s psychedelic icon. Keith has admired Leary since hearing him speak at the Nova Convention almost a decade earlier. Mutual admiration unfurls. Haring rejoices in Leary's philosophy regarding the use of LSD and feels that his own experiences with hallucinogens are confirmed and validated by Leary's ideas. His passionate reaction to Leary's writings – *Turn On, Tune In, Drop Out, The Psychedelic Experience* and his autobiography *Flashbacks* – mirrors his earlier embrace of Robert Henri's *The Art Spirit*. Leary's work becomes part of Haring's personal philosophical canon.

The fascination is mutual. Leary regards Haring as the archetypal twenty-first-century artist, a perfect amalgamation of the ideas of Dr Spock and Marshall McLuhan. Haring is a Dr Spock-generation baby, a child who is raised, as per the philosophy of the influential pediatrician, to be a true individual. Leary also sees Haring as a Marshall McLuhan baby. McLuhan was a famous media theorist, who believed that our brains are shaped by media, as opposed to media content. Leary feels that Haring – a guy

who adopted a staggering variety of media from subway drawings to badges to the naked bodies of performers like Bill and Grace – is shaping our world-view with his choice of media, more than with the actual content.

The year 1985 is also when Haring creates one of his best-remembered activist artworks, the 'Free South Africa' poster. This is a case where the medium and the message seem to have equal power. The drawing of the black giant being tyrannized by a small white figure is freely distributed at a Central Park rally, like his earlier anti-nuclear poster. Signed and unsigned versions of this non-editioned multiple are now vigorously traded on eBay.

Haring continues to play his game of chess – or is it a game of chicken? – with the art establishment into the spring of 1986. Three of his Castelli pieces are installed in the Dag Hammarskjöld Plaza sculpture garden next to the United Nations building in NYC. Haring and his sculptures make the front page of the *New York Times*. On 15 March an enhanced version of his Bordeaux one-man show opens at the historic Stedelijk Museum in Amsterdam. In lieu of the *Ten Commandments* – those giant arch-shaped paintings won't fit – Haring creates a trippy, translucent, spray-painted scrim, which hangs below the atrium skylight.

The Stedelijk exhibit garners more than its share of press after an artwork is stolen. The theft of a drawing of a Black guy being screwed by a white guy – a metaphor for the white rip-off of Black culture – is gallery-lifted during the opening. Holland being Holland, the sexually explicit image goes into heavy rotation in the Dutch news media. After extensive and well-publicized negotiation,

the drawing is returned. Scandal aside, the Stedelijk show is another huge feather in Haring's cap. His recollections of this show glow with unaffected enthusiasm and pride.

Haring is 28 years old. He may not have the US museum-world recognition he craves, but he already has multiple prestigious one-man shows under his belt. His public artworks are strewn across the globe. This year he will add to that number with a 300-metre mural on the Berlin Wall. Painted on 23 October 1986, the yellow, red and black mural – the colours of the German flag – depicts a knitted chain of figures, signifying unity. The Wall is an emotional flashpoint for German citizens on both sides. Press coverage makes the mural a target for defacement. How dare the American interloper decorate this symbol of repression with cheery hues? The mural is all but obliterated.

Haring understands by now that public art initiates a dialogue over which he has little control. In New York he has ceased his chalk drawings, which are now being cut, removed and sold. His rising profile has created a black market. Haring has been strategizing how to take better control of his own commerce. This leads to the creation of one of his best-known projects: the Pop Shop.

'Artist Turns Retailer' screeches the *New York Times* headline. On 19 April 1986, the Pop Shop opens at 292 Lafayette Street. Haring's goal is to use this retail venture to communicate directly with his public. In the article he justifies his I-had-no-choice position, explaining, 'there were so many copies of my stuff around that I felt I had to do something myself so people would at least know what the real ones look like'.

Fashion veteran Bobby Breslau is hired to manage the store and supervise the merchandising. In lieu of giving away posters and badges, Haring will sell them, along with T-shirts and items created by Kenny Scharf and Jean-Michel Basquiat, direct to the consumer at affordable prices. Haring views his store as a successful art experiment.

With the Pop Shop, Haring unwittingly created a blue-print that is still relevant today. The Pop Shop remains a primary reference point for creative retailing. Whether at Uniqlo, Dover Street, Selfridges or Louis Vuitton, the concept of any artist/fashion/merchandise collaboration owes much to the original Pop Shop. It was the pop-up shop that never popped down. It finally closed in 2005.

Haring's bustling enterprise is an easy target for those wishing to bash him. While Warhol, with his commercial illustration background and his cheeky celebration of the almighty dollar – 'Being good in business is the most fascinating kind of art' – is a big fan, many fling accu-sations of crass commercialism. Much of the art-world criticism he receives is attributable to the fact that he has bypassed the art establishment. The general public had decades to digest the newness and simplicity of, for example, Mondrian's oeuvre. By the time the famous Yves Saint Laurent Mondrian shift-dress shows up on a 1960s runway, the audience is primed and ready. Haring, on the other hand, goes straight from gallery to badges and T-shirts and – to the public, in real time – himself.

Haring fearlessly juggles his commercial side, and his activist agenda. In addition to the Berlin Wall, he also paints his legendary 'Crack is Wack' mural at FDR

Drive, near 128th Street. Haring is acutely aware of the crack epidemic, especially because his studio assistant Benny is attempting to fight his own vicious addiction. Haring's triumphant, timely mural is met with car horns and neighbourhood solidarity. Just as he is finishing up, he is arrested and given a summons. While waiting for the court date he loses no opportunity to bring his plight – and the crack scourge – to the attention of the media. He receives a $100 fine and a giant thumbs up from the general public.

The centennial anniversary of the Statue of Liberty consumes New York in the sweaty summer of 1986. Haring marks the occasion with what he describes as 'one of the best organizational feats' of his life. Working with hundreds of kids over a three-day period, he creates a multi-storey banner for the CityKids Foundation. If ever there was any doubt about the genuineness of his commitment to kids, this project addresses it. Holed up in the newly opened Javits Convention Center, Haring works with 50 kids at a time, switching in a fresh crop on a 45-minute rotation. The whole project was sponsored by Burger King and Pepsi, corporations who were happy to affiliate with America's new art star. The insanely tall banner is dangled from a building in Battery Park City, directly facing Lady Liberty herself. Yoko Ono accompanies him to the unveiling.

Continuing on the theme of scale, Haring paints the biggest skirt in the world. Grace Jones twirls it in the promo for her song 'I'm Not Perfect'. This video is a perfect time capsule that reflects Haring's new social status. The participants include Tina Chow, Nile Rodgers, Warhol and

Timothy Leary. This is around the time that he paints that denim jacket for Iman, mentioned in my introduction.

Haring's increasing sophistication and stardom are the nails in the coffin of his relationship with Juan Dubose who, as per the warnings of Bill T. Jones, struggles to get a foothold in Keith's new life and becomes increasingly depressed. At the Paradise Garage Haring meets his new lover, Juan Rivera, and separates from Dubose.

Keith's pals are bewildered by his meteoric rise, the breadth of his projects and his celebrity status. Kenny Scharf recalls this era: 'By 1985 and 1986, we all felt we lost Keith to fame, to his pursuit of famous people and fabulous celebrities, and by surrounding himself with these gay Puerto Rican hustlers.' His new lover has a different take: Juan Rivera, Dubose's successor, recalls a happy domestic life. Keith worked all day. Juan cooked and cleaned. They watched cartoons, *Mister Ed* and *The Honeymooners* on TV. One suspects the truth lies somewhere in the middle. The caring pilgrim and the spotlight-seeking rake are walking hand in hand.

December 1986: Haring unveils his next Shafrazi show. As usual he produces the paintings at breakneck speed, one week prior to installation. In this instance, his sling-it-all-together-at-the-last-minute approach produces a show that he describes as 'uneven'. A series of oversized tribal masks, enamel on aluminium, emerges as the show's highlight.

1987. When Bobby Breslau dies from complications caused by the AIDS virus, Haring loses an important wingman. Breslau is more than just the overlord of the Pop Shop; he, the older gay man, is also a parental figure

and moral compass. Haring is traumatized. He describes watching Bobby's death from AIDS as 'pure agony'. In his journal Haring declares his intention to commit suicide in the event that the HIV reaper comes calling for him. Most 28-year-olds are not watching pals perish or anticipating their own deaths, but this is the 1980s and the gay men in Haring's circle are dropping like flies. Haring accepts that he is probably next. Maybe he has five months, maybe five years. With death hovering in the rearview mirror, Haring's commitment to making art, communicating his message, helping kids and building his profile becomes more fervent than ever. He resolves 'to do as much as possible as quickly as possible'.

On 22 February, another mentor dies. Andy Warhol's terror of hospitals has caused him to neglect a gall-bladder, which has become gangrenous. By the time he is on the operating table he is malnourished and dehydrated. His daily dose of speed does not help matters, nor do the long-standing injuries – nine damaged organs – resulting from the infamous Valerie Solanas shooting a decade earlier. Post gall-bladder surgery, Warhol's heart stops. A nurse finds him unresponsive. Haring is in Brazil with Kenny Scharf when he gets the shocking news that Warhol has died. Stunned and unsure of what to do next, they light a big memorial bonfire on the beach.

Haring has come to rely on Warhol for reassurance and encouragement. Warhol, with his unconventional, pop, commercial approach, built the ladder that he, Haring, has been climbing. There is a certain logic and inevitability to their connection. Warhol challenged the sacredness

of art, as did Haring. Warhol was always an outsider. He was kept at arm's length by the art world in his early years. Swishy Andy, who loved flowers and shoes and drag queens and movie stars, was a curious and intelligent artist who surveyed the world through a prism of irony, fun and camp. The fun factor, the playful gregariousness that was so important to Haring and his Club 57 generation, was previously championed by Warhol and made him the perfect gay uncle for Haring and the other artists of the 1980s. Despite his legendary 1960s icy detachment – 'I want to be a machine' – Andy became a caring sounding-board and mentor to both Basquiat and Haring.

It is important to point out that their relationship with Andy was symbiotic. The mentoring and collaborating had obvious pay-offs for the older man. His association with the new wave of artists, half his age, made him relevant again. A decade earlier, Warhol was hanging out with Betty Ford and Liz Taylor at Studio 54. Now, thanks to his hip young wards, he had become a key player in the burgeoning new cultural scene.

Haring charges into 1987, minus Andy. He lectures at Yale; he pulls off six solo exhibits. He also collaborates with choreographer Jennifer Muller on a dance piece called *Interrupted River* at the Joyce Theater on Eighth Avenue, providing a splendid backdrop. Yoko Ono writes the music.

During the course of this action-packed year he paints five murals in various locations in the USA, including an aquatic-themed frieze with cavorting swimmers and dolphins at the Carmine Street Pool in Greenwich Village.

Haring's star is rising globally, but most unquestioningly and enthusiastically in Europe, where his playful lack of tradition is seen as refreshing. Just like Warhol in the 1960s, he is exactly what Europe wants from an American artist: colourful, pop, culturally relevant and totally informal – an antidote to all that encumbering European history.

In the spring of 1987 he packs his bags for a three and a half-month tour. First stop, Paris. In conjunction with the tenth anniversary of the Centre Pompidou, Haring paints a mural on an eight-storey stairwell at the historic Necker children's hospital (the encased stairwell resembles the cardboard tube, slightly squashed, which lurks inside a roll of paper towels). New boyfriend Juan Rivera assists Haring with what turns into a gruelling three-day outdoor installation. A massive crane dangles a small six by eight-foot box containing a weather-beaten Haring and Rivera.

Haring celebrates his 29th birthday at Le Train Bleu, an old-school glitzy restaurant located in the Gare de Lyon. Artists in attendance include George Condo, James Rosenquist, James Brown and Donald Baechler. Haring and Rivera stay in bed most of the next day, hoping foul weather will subside so they can finish the Necker mural.

Among Haring's new pals is Claude Picasso, son of Pablo. Haring bonds with his daughter Jasmin, playing drawing games just as he did with baby sister Kristen. Claude and his wife invite Haring to paint the door of Jasmin's room. Watching Haring at work, Claude observes some basic similarities between Haring and his relentlessly driven father. Like Pablo, Haring paints ferociously until finished, and then stands back to digest the completed work.

After a quick detour to Japan to plant the seed for a possible Pop Shop Tokyo, Haring returns to Europe to contribute his talents to the legendary Luna Luna Park in Hamburg. The concept of a travelling artist-designed funfair is the brainchild of a Viennese artist named André Heller. Other participating artists include Hockney, Beuys, Basquiat, Scharf and Dalí. After being offered a variety of fairground options, Haring chooses a carousel, which seems like a metaphor for this final whirring, flashing, distraction-filled act of Haring's life.

Haring then spends three weeks in Belgium producing work for various institutions, including a one-man show at the Knokke Casino. Like the Luna Luna commission, this casino project at first sounds tacky, but is in reality immensely prestigious. The Knokke Casino is famous for its art collaborations, including a large mural painted by René Magritte. For his show Haring produces paintings and a permanent mural that has a distinctly early Haring look to it, recalling his interlocking shapes – his Dubuffet period – a decade earlier.

In lieu of a posh hotel, Haring stays in a sculptural house created by kindred spirit Niki de Saint Phalle. He spends his days furiously making art in a nearby converted tea room, formerly named the Penguin. He is living his best, swankiest and most bohemian life. His dish-washing days are safely behind him.

During this period Haring makes a couple of journal references to the fact that he is reading Joe Orton's diaries, which had been published the previous year. The strange story of two gay men – one an intensely creative and

successful playwright, the other resentful and eventually homicidal – was devoured by every gay man of my acquaintance during this period. In London Haring rushes to see the movie *Prick Up Your Ears*, starring Gary Oldman as Orton. Haring is familiar with extreme relationship imbalances. One can safely assume that the gruesome story resonates.

Haring feels, not unreasonably, that this is the most productive, stimulating period of his life. Looked at in retrospect, this mad summer was the apex of his career. Towards the end of this halcyon Euro-interlude, while finishing up the Knokke mural, reality intrudes when Haring gets a call from a reporter in the States. Are the rumours true? Are you hiding out in Europe while secretly receiving AIDS treatments?

Back in New York – via Concorde – Haring swings back into action, and is able to dispel rumours about his health. The plague, however, is never far from his thoughts. Haring's ideas about the origins of the virus tend towards the conspiratorial. He wears a T-shirt that reads 'AIDS is Political-Biological Germ Warfare'.

8

The Tolling of the Bell

The final 25 and a half months of Keith Haring's life – January 1988 until 16 February 1990 – are packed with extremes. Exuberant globe-trotting and creativity unfurl against a backdrop of death and despair. The extremes collide in some of the work – confrontational safe-sex posters and strange, sinister ink drawings – that is produced during this period. As curator Elizabeth Sussman states in the catalogue to Haring's 1997 Whitney retrospective: 'Finally, in the last years of his life, major works not only summed up his painting ambitions but were socially active and angry responses to his imminent death.'

The year gets off to a lively, if jet-lagged, start with the January opening of Pop Shop Tokyo. Rather than go the conventional route of collaborating on a shop-in-shop at one of the mega-department stores like Parco or Isetan, Haring goes rogue. Plonked on a vacant lot, the innovative store is constructed out of shipping containers, a harbinger of the Boxpark that opened in London's Shoreditch in 2011. Prepping the store turns into an operational nightmare, with myriad construction issues, a looming deadline, neck-ache from painting floors and ceilings, and not much rest. Every morning Haring is woken at 8.30 by a school marching band practising behind his hotel.

How, one might reasonably wonder, does Haring keep all the balls in the air? His international schedule, the global demand for his oeuvre and flow of requests are all unremitting. Dealing with the faxes and the bonkers travel itinerary is his long-time and, one suspects, long-suffering factotum and strategic collaborator Julia Gruen, who is also on the Japan trip. (After Haring's death, Julia went on to become executive director of the Keith Haring Foundation.)

Haring's journal provides insights into the teeth-grinding frustrations that now accompany his astonishing success. Driven by his natural impulse to be inclusive, Haring has generously and recklessly invited an extensive entourage along on the Tokyo trip. Playing the role of Maria von Trapp proves challenging. Not everyone in his group is as grateful for this ten-day junket as might have been expected. Factions form. Complaints fly, often about the food. Keith becomes irate, especially with his lover Juan Rivera. Unannounced, Juan bolts to the airport and flies home. Haring is shocked and upset.

In July 1988 Haring finds himself yet again back in Japan, attempting to get the now struggling Pop Shop back on track. The purpose of this trip is also to initiate discussions about a possible Hiroshima mural. One evening he is in his hotel room reading a book titled *Cities on a Hill* by Frances FitzGerald. One particular section describes a gay man inspecting his skin every day for signs of Kaposi's sarcoma, the cancer that is associated with AIDS. Scrutinizing his own body, he finds a tiny purple spot on his leg. By the time Haring gets back to NYC, the spot has disappeared, but there is another on his arm. A biopsy and his plummeting T-cell count reveal the truth.

When Haring is officially diagnosed with AIDS, he goes down to the East River and has a very protracted and very profound weep. This is the moment he has been anticipating for a couple of years, but it nonetheless does him in. It is important to understand that an AIDS diagnosis at this time was no mere ordinary death sentence. It was also a moral condemnation. Gay men of Keith's generation had to navigate a minefield of rejection and moral judgment. For many Reaganites and homophobes, AIDS was seen as a biblical and appropriate punishment for the self-acceptance and liberation that the homosexuals of the 1970s had dared to enjoy. Under these circumstances many young men killed themselves, quickly or slowly, found God, or disappeared to go live in the wilderness and were never seen again. Not our Keith.

Haring is no shrinking violet. This is the guy who delivered newspapers on frosty mornings, hitchhiked across the country, worked as a maintenance guy in order to gain access to classes in Pittsburgh, and painted a massive chunk of the Berlin Wall in one day. Tenacity and resilience are in his DNA. After the emotional release by the East River comes the realization that, despite being afflicted with the disease of the century, he must forge ahead. He is a fighter, not a complainer. AIDS not only motivates him to live in the moment, it imbues his art with new energy.

In the early summer Haring is given an assignment by *Spin* magazine. He is handed a camera and told to go and photograph street fashion in New York City. While meandering down Broadway, he bumps into Jean-Michel Basquiat. He explains his assignment, whereupon Basquiat

becomes a little jealous. How come they never ask me? Despite being somewhat miffed, Jean-Michel enthusiastically agrees to pose – 'I'm dying to be in *Spin*' – and lays down in the street like a homeless person. This is a touching window into the fragile egos of two young, successful artists with the world at their respective feet, still on the lookout for slights, but struggling to keep up with the flow of exciting projects and general adulation that comes with success. Earlier in the year Haring had visited the Frank Stella retrospective at the Museum of Modern Art. Despite the shimmering excitement of his career, he comes away wringing his hands and trying to understand why the large US art institutions are overlooking him.

RIP Samo. One month after the *Spin* encounter Basquiat dies of a heroin overdose, leaving an estate valued at $10 million and joining the '27 Club', which at this juncture includes Jim Morrison, Janis Joplin and Jimi Hendrix. Amy Winehouse and Kurt Cobain are waiting in the wings.

In September 1988 Haring heads to Düsseldorf, where he fabricates and exhibits his largest sculptures to date at the Hans Mayer Gallery. He clearly revels in this medium. Three-dimensional monumental sculpture is every bit as impactful as outdoor painting, but with added permanence. Sculpture has one big advantage over murals: it is a form of public art which, although it can be tagged, cannot be obliterated. Had he lived, there is no doubt that Haring's sculptures would only have become more ambitious and more ubiquitous.

December: time for another Shafrazi show. The show invite consists of a melancholy aquatic doodle. A grotesque

figure blows soap bubbles into a world of fleeing birds, deformed fish and barbed snakes. Some of the bubbles resemble viruses. Inside one of the fragile bubbles is a photo of baby Keith playing in a paddling pool. This show – his final Shafrazi moment as a living artist – is loaded with import. After the death of Warhol and Basquiat, Haring feels he has something to prove. Haring memorializes his friend in a painting entitled *A Pile of Crowns for Jean-Michel Basquiat.*

The show sells well but the absence of a review in the *New York Times* or *Artforum* is keenly felt. Shafrazi says that the big institutions are resisting an embrace of Haring because he has committed the sin of going out on his own and developing an audience. The US museums and institutions like to be the ones to decide if somebody deserves an audience. Haring bypassed them, and now they are bypassing him. Postcards in the MoMA gift shop, yes, but no one-man shows for you. Tony also feels that the accessibility and broad appeal of Haring's work – how dare you make colourful, playful art that connects to such a broad range of real people? – is a strike against Haring in the eyes of the US arterati. As Shafrazi puts it, 'Any work that addresses and reflects a more populist language will be disdained by the art establishment.'

For the remainder of his life Haring will find consolation in Europe, where he enjoys an unambiguous acceptance. The exuberant embrace of the European art establishment inspires Haring to produce some of his best work.

1989. After his AIDS diagnosis, Haring craves substantive dialogue. He finds it with Timothy Leary – a sticker with

the words 'JUST SAY KNOW – Tim Leary' adorns the door of his New York studio – and also William Burroughs, with whom he has recently created a series of collaged drawings titled *Apocalypse*.

Haring also finds verbal solace with a handsome heterosexual named Gilbert Vazquez, a young lad he encounters on the street in front of his studio. Their apparently platonic relationship is about support and companionship. Vazquez is more educated than the previous men in Haring's life. He has an easier time dealing with the role of companion to a superstar artist.

The Shafrazi show comes down in January 1989. Around this time, Juan Dubose is hospitalized with AIDS-related tuberculosis. Haring recollects his final hospital visit as follows: 'When I leave, Juan reaches up to kiss me goodbye. At the door, I turn and wave goodbye to him. The next morning, Juan's mother calls to say Juan has died.'

Mourning the loss of Juan and in desperate need of distraction, Keith, accompanied by Gil, flies the Concorde to Paris and checks into the Plaza Athénée for a vacation of gourmandizing, museuming and socializing with his cultivated and glamorous group of friends. They take mushrooms and go clubbing at Les Bains Douches and Le Palace. Gil punches an obnoxious dude in the face. They eat pastries and walk around the Eiffel Tower in the early morning. They crash into bed and fall asleep. 'It's too fucking perfect', writes Haring in his journal.

Haring's friendship with Claude Picasso delivers unexpected side benefits. His stepfather is Jonas Salk, the noted AIDS researcher. Salk gives Keith advice about

how to juggle his meds. This is the period when AIDS patients are experimenting, and being experimented on, with AZT and Zovirax and DDI. Haring now has a KS lesion in the middle of his forehead. Many gay men, thus afflicted, retreated completely from the world. Not Haring.

His journal for 1989 is packed with glamorous destinations – Barcelona, Morocco, London – and a rich flow of namedropping: Grace Jones, George Condo, Yves Arman, son of artist Arman, and wacky socialite of the moment Princess Gloria von Thurn und Taxis. He hops from city to city, making every attempt to record the details of this period in his journal.

On 15 February Yves Arman dies in a gruesome car wreck. Haring's close pal is driving his father's Porsche from Monte Carlo to Madrid to meet Haring and to attend the Art Fair. Unable to sleep, or contain his emotions, Haring walks to the Prado and paces up and down. Then he finds a black high heel lying in the street. It's a scene right out of a Buñuel movie. Haring sees this as a moment of profound poetic melancholy. His journal entry reads: 'My life, my misguided love, my friends, suffering, pain, and little bursts of sanity.'

On 9 March, Robert Mapplethorpe dies from AIDS complications. Haring is haunted by a strange coincidence: while driving in Morocco he is randomly daydreaming about Mapplethorpe – his illness is the talk of the art world – envisaging the announcement of his death and visualizing his funeral. The next day he opens the newspaper and spots the obituary. He figures out that he was daydreaming about the ailing photographer at the exact

moment that he died. Haring had a similar experience prior to Yves Arman's death. These moments lead him to speculate that he might have the ability to sense the passing of his friends. This belief goes back to his 1978 trip to the Nova Convention and his ideas about symbols and signs, chance and coincidence. Haring and William Burroughs clearly had a mystical connection, one that is hard to fully understand. After collaborating with Haring, Burroughs describes him as 'spectral'. This description also applies to Burroughs himself. One cannot help wondering if maybe they had both dropped a little too much acid.

On 17 March, Haring flies Concorde back to the USA. One month later, accompanied by Julia Gruen, Haring flies Concorde again, back to Europe to attend the jet-set party of the decade, thrown by the aforementioned Princess Gloria von Thurn und Taxis. Referred to in the media as the 'Punk Princess' and 'Princess TNT', the princess was known for her extreme fashion addiction and lavish lifestyle, as well as the vast age difference between her and her husband. Haring has designed the invite – packaging for a CD of Gloria singing the invitation to her pals – and the place settings for the big soirée. The party is a bacchanal of rock stars, sports icons and entertainment celebs. Haring dances with a group who have taken Ecstasy. If he had lived into the 1990s, Haring undoubtedly would have dived into the rave/Ecstasy scene. The fluorescent hues and infantile aesthetic were, after all, inspired by Haring's generation.

All this rabid, trendy, glamorous socializing is interspersed with some of the most substantive projects of

Haring's career. From 15 to 19 May, Haring works tirelessly with 500 schoolkids to paint a mural in Grant Park, Chicago. A local teacher named Irving Zucker initiated this monumental undertaking, whereby 122 four-by-eight panels of Masonite are configured into a wall that is almost 500 feet long. Haring dives in first and paints a series of interlocking shapes in the style of his Pop Shop mural. In the subsequent days – a period officially dubbed 'Keith Haring Week' by Mayor Richard M. Daley – students fill in the white space, working in five colours: red, orange, sky blue, light green and yellow. While De La Soul plays on a boom box, Haring encourages the kids to take creative licence and personalize their spaces with tags, nicknames, and personal and political messages. Documentation of the creation of this wall shows kids in Haring T-shirts and caps, sloshing paint around and having a blast. The mural scythes through the park in a way that recalls an early Haring obsession, Christo's *Running Fence*. Before leaving Chicago, he paints two walls at St Luke's Medical Center.

In June Tseng Kwong Chi and Haring find themselves renting a small plane in Calais in order to photograph an incoming blimp. As part of the 1989 French Revolution bicentennial, Haring has been invited to paint one side of this dirigible, which is scheduled to make its way from the UK, flying over Paris at the appointed hour (at the last minute this is vetoed by French authorities, hence the need to photograph it arriving in Calais). Haring's side of the blimp – the other facet is painted by a Russian artist named Erik Bulatov – depicts dancing scissors cutting a snake in half, and causing it to vomit blood. The snake, one assumes,

represents the Bourbon dynasty and the scissors are the triumphant revolutionaries. A proud Haring describes the painting as one of his best. Marshall McLuhan would probably say that the medium – that absurd Monty Python blimp – is actually the real message.

The story of how Haring came to paint a mural in the side wall of a church in Pisa is Haring-esque in the extreme. In other words, it perfectly illustrates his willingness to surrender to fate and serendipity. One day Haring spots a bunch of Hare Krishnas plucking sitars in a van opposite his studio in NYC. He notices that one of the young men – a very angelic beautiful lad – is staring at him. They strike up a conversation. It turns out the boy is from a family of well-to-do wine merchants, and Haring fans, based in Pisa. After father and son make a studio visit, they promise to secure an outdoor painting project for Haring. Cut to June 1989: Haring arrives in the ancient city to paint an exterior wall of the church of Sant'Antonio. The friars serve him dinner. He finds them refreshingly progressive and aware. Once the painting begins, a mardi gras scene unfolds with strolling locals, paparazzi, gorgeous boys and breakdancers, part Fellini, part Pasolini. This Dolce Vita atmosphere inspires the artist. The resulting mural – a vibrating, pulsing, Technicolor configuration of angels, Madonnas, babies, birds, saints and rogues titled 'Tuttomondo' – is one of Haring's most spectacular.

Meanwhile, back in the USA, the August 1989 issue of *Rolling Stone* is dominated by a lengthy, candid profile of Haring written by David Sheff. His courageous AIDS disclosure rocks the world, especially the good people

of Kutztown, and especially the Harings. According to Kermit, Keith had never before used the word 'AIDS' around the family. His beloved radiant baby sister Kristen only found out he was sick two weeks before the article came out. His bold on-the-record honesty must be seen in context, and loudly applauded. This is the era when prominent people hid their diagnoses from the world for fear of losing their prestige, and everything else. The article also unpacks and clarifies his ideas about chance and coincidence, which frankly, dear reader, I have always struggled to grasp.

Haring's journal fizzles on 22 September, but his projects and his frantic travelling continue. On 18 November he arrives in Monaco with his parents and office staff, Margaret Slabbert and Julia Gruen. He is being presented with an award, an official thank-you for the mural he has recently painted in the Princess Grace children's hospital. The mural will be dedicated to Yves Arman. Rather than risk being late for his appointment with HRH Princess Caroline, Haring charters a private jet to fly from Germany to Monaco.

For the palace ceremony, Keith arrives sweating, and only half an hour late. He wears an Armani suit shirt and tie with his signature Nike Delta Force high-top sneakers, proving that he was, if nothing else, a fashion avatar. This look – the sportif sneaker worn with a sharp suit – would take decades before gaining acceptance. Haring did it first. He receives his Order of Cultural Merit dressed – at least as far as the palace officials were concerned – like a mental patient.

The frantic, distracting globe-trotting continues. Keith flies back to Germany to paint the chassis of a red

1990 BMW convertible. He is, clearly, learning to put his ideological loathing for the world of big business on the back burner, especially if it puts him in the company of previous BMW collaborators Warhol, Lichtenstein, Stella and Alexander Calder.

In December the virus suddenly starts to win the battle. Normally Keith dedicates a significant amount of time to prepping for Christmas, making gifts for his extensive circle. This year he is too tired. He switches his meds. He gets weaker. His Kaposi's sarcoma is now accompanied by a good old-fashioned case of lymphoma.

He holes up in his new duplex apartment on LaGuardia Place, which has been decorated at Haring's request in the zhooshy style of the Ritz of the Place Vendôme. The walls are now lined with his favourite art, including works by Condo, Basquiat, Warhol, Lichtenstein, Picasso, Clemente, and a television painted by Kenny Scharf. He is visited by Gil, his friend Lysa Cooper, his studio assistant Adolfo, and an ailing Juan Rivera, who is battling AIDS without medical intervention. He is relying on his faith.

In February Haring drags himself to his studio to work. He has severe, agonizing laryngitis, which prevents him from speaking. He aborts the attempt to paint and draw and returns home, where he goes into a rapid decline. On 12 February he is barely able to hold his Rapidograph, but somehow manages to draw a radiant baby. He dies on 16 February 1990 at 4.40 am, aged 31.

* * * * *

A memorial is held in Kutztown on 3 March. After the service a festive, intergenerational gathering of Harings and friends climb a nearby hill to a place where Haring cavorted as a child. Each of the 50 mourners takes a handful of ashes and scatters them in the surrounding meadow.

On 4 May, 1,000 people gather in the Cathedral of St John the Divine in New York City to celebrate – with performances and speeches by everyone from Jessye Norman to Dennis Hopper and members of CityKids – the glamour, generosity, tenacity, bravery, positivity, creativity and life-enhancing fabulosity that was Keith Haring.

Have You Seen Kanye's New Haircut? A Post-mortem

In November 2019 I leave my apartment in Greenwich Village to run a few errands. In the course of that single day I have multiple encounters with the ghost of Keith Haring.

On Greenwich Avenue, next to the AIDS Memorial Park, I clock a newly installed large framed outdoor poster: 'Stop AIDS, Haring 1989'. Those green anthropomorphized scissors snipping a red snake in half bring back memories of the AIDS epidemic and pilgrim Keith's efforts to usher a little hope and wit into the valley of death.

On the racks of Saks Fifth Avenue, opposite Rockefeller Center, I peruse a men's fashion collection called *Etudes*, which has boldly incorporated Haring line drawings and the three-eyed face onto blood-red hoodies. Later, down on Broadway, I screech to a halt outside a window display promoting a new Keith Haring × G-Shock line of watches (calling to mind Haring's 1985 collaboration with Swatch). Also on Broadway, the Uniqlo store is offering a full complement of Haring-emblazoned T-shirts at $14.95 a pop. Meanwhile on eBay, all those 1980s freebie posters and badges are vigorously traded. In 2018, two of Princess Gloria's old dinner plates sold at Sotheby's for £2,250. The entire world has become a Pop Shop.

And it's not just the commercial stuff. Since Keith Haring's death there has been a continuous cortège of one-man museum and gallery shows. In any given year there are at least half a dozen prestigious Haring homages dotted across the globe, including – Haring would be shocked at the continuous high-profile exhibitions that are staged in his homeland – the USA. From Liverpool to Gwangju to Katonah, enthusiasm for Haring is not just unwavering, it is exploding.

This is also reflected in the auction values. Most recently, a 1988 Haring painting – a pink triangle titled *Silence = Death* – sold for $5.5 million. The art of Haring – resonant with the golden age of 1980s new wave and hip-hop – has become a must-have tattoo, a signifier of connoisseurship, on the walls of moneyed collectors.

Rarely a year goes by that a flaking Haring mural is not restored. In 2019 'Crack is Wack' was brought back to its former glory. The mural in the bathroom of the LGBT Community Center on 13th Street was restored in 2015. In 1997 the Carmine Street Pool mural sparkled once more. The Grant Park mural in Chicago has been partially reassembled and exhibited. Even that inaccessible funnel at the Necker hospital in Paris was brought back to life, by two artists named William Shank and Antonio Rava, who also restored the 'Tuttomondo' mural in Pisa. The dude who wanted to give the people the art they deserved is continuing to do so.

Who would Keith Haring be if he were alive today? He would be an activist, fighting for LGBTQ rights and calling out racism. He would also, let's face it, be moving

in elite bohemian circles with bold-faced names. He was an *homme du peuple*, but he was also a glamour-obsessed gay from a small town who loved fancy hotels, style and flash. I envisage him collaborating with Louis Vuitton – à la Yayoi Kusama – revelling in the opportunity to bring his message into the world of luxury. I see him dining at a chichi French restaurant after receiving the Légion d'Honneur while a grizzled George Condo and Claude Picasso, with his grown-up daughter whose door Keith painted, applaud enthusiastically. He would be hanging with KK and Kanye West. The latter recently commissioned Haring drawings to be shaved into his scalp. And he would experience career peaks and valleys.

Although Warhol died aged 58, he lived long enough to see interest in his oeuvre wax and wane, and then wax again. Haring would have had the same trajectory. He would have survived, as Warhol did, by connecting with the next generation. Why wouldn't Haring be collaborating with Damien Hirst, the Haas Brothers or Sterling Ruby? He would undoubtedly have promoted the new generation of Latinx and Black artists. Having gone completely bald, he might even have resorted to wearing an Andy wig.

And he would, undoubtedly, have had kids. Many radiant babies. When Haring was a young gay man – the rakish habitué of the Club Baths – the notion of gay parenting was not on the table. Times have changed, and in the twenty-first century Keith would have been first in line to make a family of his own, just like his old pal Madonna. Yes, he would have been an old dad – 60 years old in 2018 – but he would have been a great dad.

Haring predicted his post-mortem life. After Andy Warhol died in 1987, he wrote in his journal: 'I'm sure when I die I won't really die, because I live in many people.' Haring lives on in the people who promote and restore his work, and in those who simply encounter his work and are moved by it in some way, which is basically everyone on the planet. He even lives on in the endless copies and the Haring-esque homages.

Though epitomizing the 1980s in many ways, Haring's work does not evoke nostalgia. The fact that he has been dead since 1990 is barely relevant. When young people discover Keith's work, they are enlivened and charmed by it in a completely fresh, contemporary way. He lives on in their joy and amusement. He is still groovy.

Further Reading

Keith Haring, *Keith Haring Journals* (London and New York: Penguin, 2010)

Jeffrey Deitch, Julia Gruen and Suzanne Geiss, with contributions by Kenny Scharf and George Condo, *Keith Haring* (New York: Rizzoli Classics, 2014)

John Gruen, *Keith Haring: The Authorized Biography* (New York: Prentice Hall Press, 1991)

Andy Warhol, *The Andy Warhol Diaries* (New York: Warner Books, 1989)

Michael Dayton Hermann, ed., with the Andy Warhol Foundation for the Visual Arts, *Warhol on Basquiat: The Iconic Relationship Told in Andy Warhol's Words and Pictures* (Cologne: Taschen, 2019)

Index

Index

Picture Credits

(numbered in order of appearance)

1. Photo by Laura Levine/Corbis via Getty Images

2. Photo by Patrick McMullan/Getty Images

3. Photo by Barbara Alper/Getty Images

4. © Ron Frehm/AP/Shutterstock

5. © Ben Buchanan/Bridgeman Images

6. © 1985 Croe/Mediapunch/Shutterstock

7. Photo by Janette Beckman/Getty Images

8. Photo by DMI/The LIFE Picture Collection via Getty Images

9. Photo by Patrick McMullan/Getty Images

10. Photo by Ron Gallela/Ron Gallela Collection via Getty Images

11, 12. Photo by Patrick McMullan/Getty Images

13. Photo by Stiebing/ullstein bild via Getty Images

14. Nick Elgar/Corbis/VCG via Getty Images

15. Photo by Catherine McGann/Getty Images

16. Photo by Owen Franken/Corbis via Getty Images

17. Photo by Rose Hartman/Archive Photos/Getty Images

18. Photo by Catherine McGann/Getty Images

19. Photo by GYSEMBERGH Benoit/Paris Match via Getty Images

20. © 1990 Sipa/Shutterstock

21. Photo by James Leynse/Corbis via Getty Images

Acknowledgements

I would like to thank the staff at Laurence King Publishing, in particular Felicity Maunder, Donald Dinwiddie, Marc Valli, Peter Kent, Florian Michelet and Simon Walsh.